Drawing
Clothed Figures

Dedication

I would like to dedicate this book to my Dad, who always had a good grasp of people, and passed on this gift to me. It would be nice to think that he would have been quietly proud of what I have set out to achieve.

Drawing
Clothed Figures

Lucy Swinburne

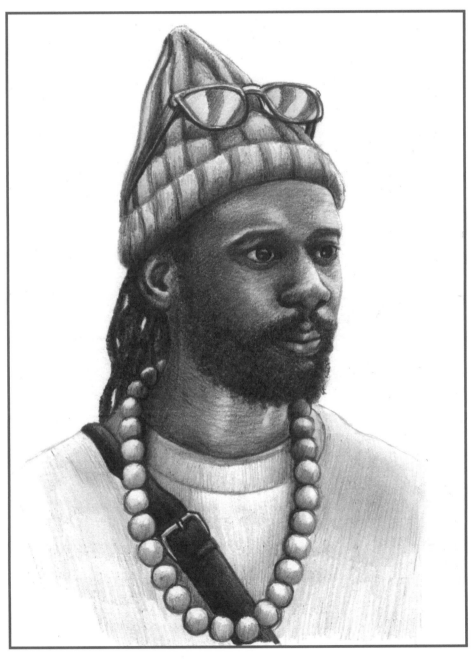

SEARCH PRESS

First published in 2016

Search Press Limited
Wellwood, North Farm Road,
Tunbridge Wells, Kent TN2 3DR

Illustrations and text copyright ©
Lucy Swinburne 2016

Photographs and design copyright ©
Search Press Ltd. 2016

ISBN: 978-1-78221-079-5

The Publishers and author can accept
no responsibility for any consequences
arising from the information, advice or
instructions given in this publication.

Suppliers
If you have difficulty in obtaining
any of the materials and equipment
mentioned in this book, then please
visit the Search Press website for
details of suppliers:
www.searchpress.com

Printed in Malaysia

Acknowledgements

Thanks to the following for allowing me to use their photographs
as reference: Dave Broadbent, Antonella Rossi, Scott Pearce,
Li Newton, Kinga Omelczuk, Freda Austin Nichols, Richard Long,
Ann Campbell, Ruth Archer, Rosalind Amoria, Steve Lyddon,
Franklin, Karina, Neil A. Kingsbury, Ahmed Farahat, Manneherrin,
Keith Evans, Caroline Hughes-King, Robyn (Ro) Lovelock, K. Brooks,
Sheilah Plumley, Audrey Campbell, Natalie Swinburne, Rudi Roels,
Donna Sommer, ESP, Christine Coffey Rosie (The Closet Painter),
and Harold Hopkinson.

Front cover
Taya
31 x 40.5cm (12 x 16in)
Graphite pencils on smooth white board.

Page 1
Victoria Ballerina
31 x 40.5cm (12 x 16in)
Seated pose in pastel pencil on smooth deep purple card.

Page 2
Bowie
31 x 40.5cm (12 x 16in)
Graphite pencils on smooth white board.

Page 3
Caribbean Man
31 x 40.5cm (12 x 16in)
Graphite pencils on smooth white board.

Opposite
Anto's Husband and his Dog
21 x 29.7cm (8¼ x 11¾in)

*Graphite pencils on smooth white board. Graphite pencils were perfect to show
the texture of the figure's clothing to its fullest extent. A 2H was used for the
main sketch followed by a 2B and a 4B to get the darkest darks. The background
was mainly drawn using the 2H pencil to give a fading, faint impression in order
not to distract the viewer from the main subjects in the foreground.*

Contents

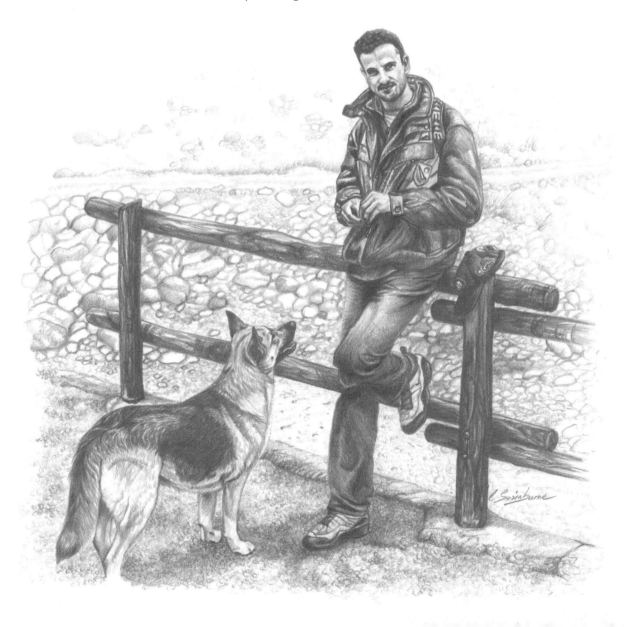

Introduction

Drawing people can seem a daunting task. How do you capture their mood, that particular pose, their expression? Before you reach even that stage, there will be many people all too keen to point out that you first need to learn all about proportion and perspective – oh, and anatomy and measuring by eye...

While it is true that all those things are necessary to drawing a good sketch or creating a fabulous painting of a person, I believe that the main ingredient required is a passion to learn. Without that passion and the willingness to discover and practise, not even all the knowledge in the world will help you to achieve anything!

This book will show you how to draw people from the very first principles. If you are already an intermediate artist, it will help to confirm what you already know, while encouraging and developing your creativity. I hope that it will also inspire those readers who are already very capable artists to continue pushing themselves and to give them the confidence and guidance they need to continue growing.

The contents of this book will show you how to tackle drawing the clothed figure and how to portray people in different situations of daily life. The methods are focused on creating an understanding of the particular moment in time you have chosen. You will see how clothing is affected by the person's stance, their pose and how it creates a story and how you can portray a person's mood even if there is little or no facial expression on display. Throughout the book I will show you the different drawing media available, how to choose the reference material from which to work, how to recognise anatomy even under drapery and clothing, and how lighting affects the clothed figure.

At some point, drawing from a live model is essential for learning about how the body is connected. Drawing your chosen figure from life promotes free thinking and will enable you to comprehensively learn about drawing in a way that photographs cannot teach on their own. However, it is much easier to begin with photographs – and less embarrassing if you do not like being under scrutiny – so we begin by using them before learning how to move on to drawing from life.

In short, I want you to enjoy drawing people, whatever your level of ability. None of us is too old to learn.

The Twins
51 x 40.5cm (20 x 16in)
Graphite pencils on smooth white board.

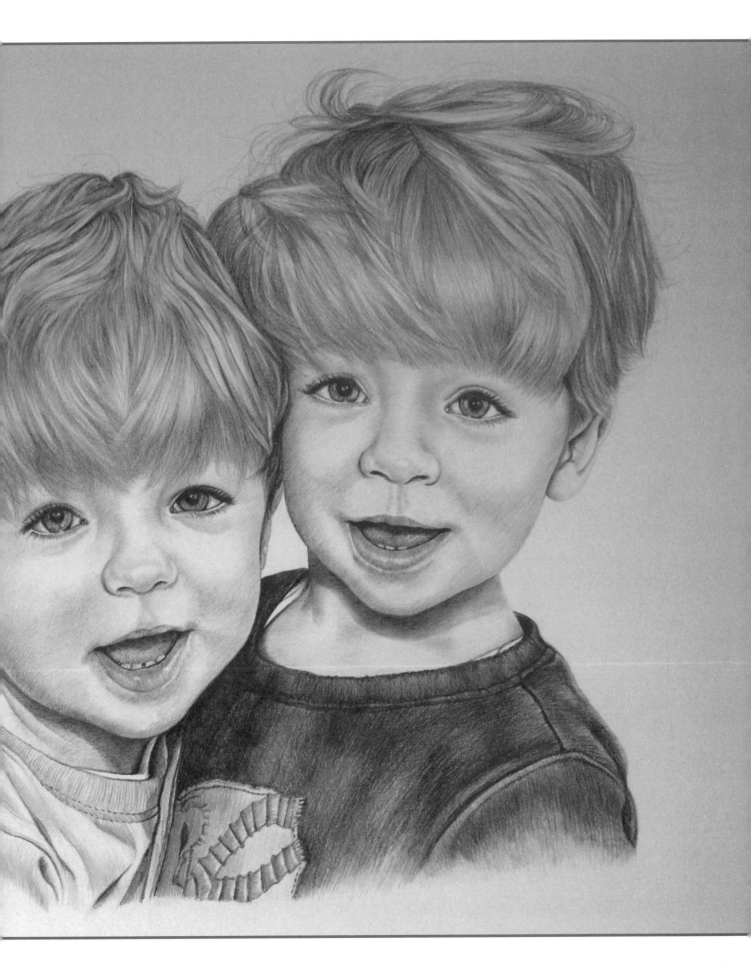

The history of figure drawing

Drawings of clothed figures fall under the more general heading of 'portrait', a term which encompasses clothed or nude subjects, drawn outdoors or inside, and includes more unusual compositions such as the subject mounted on a horse or as part of a group. Portraits can be informal or formal, and any medium can be used. The very idea of a portrait – and thus drawings of clothed figures – is to not only show a likeness to the subject but also to reflect their inner qualities too.

Drawings of people can be traced back to prehistoric times. We are all familiar with paintings and statues of the rulers and gods of Ancient Egypt. These portraits were usually depicted on stone, metal and clay and the portraits were stylised and iconic rather than naturalistic. When painted, the figures were almost always in profile, with stiff and unshaped clothing. There was little emphasis on likeness until the later part of this period.

Surviving Ancient Greek paintings, statues and sculpted busts of important figures like Socrates show an obvious attempt to depict the figure as they really looked, rather than as an idealised image. Drapery and clothing became increasingly well-realised and observed through this period.

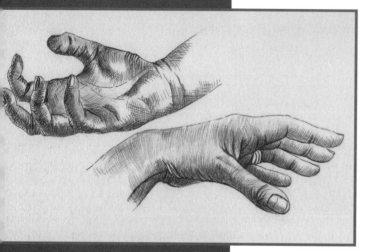

Hands in the style of Dürer

20.5 x 31cm (8 x 12in), graphite pencil on smooth white card.

The Romans also used portraiture in paintings and sculpture, and there are many surviving examples to be seen across Europe and beyond. They also created thousands of coin portraits. After the fall of Rome, portraiture in the West declined in realism, with figures and their clothing becoming increasingly stylised. Formal portraits from the Classical through the mediaeval periods usually portrayed the sitter very formally and soberly, with little facial expression. It was expected that portraits would show the sitter with a closed-lip expression or at most a half smile. Often, it was up to the artist to convey as much emotion and character as possible through the subject's eyes and use the eyebrows to help expand on this wherever possible.

In the Middle Ages in Europe, around 1350–1400AD, the method of obtaining a likeness in a portrait became more keenly observed, but clothed figure portraits still remained the preserve of popes, royalty or other nobility. Owning such paintings and sculptures gave you status, but this meant that commissioning such a painting was an option only for the wealthy.

CLOTHED FIGURE ART
AFTER THE RENAISSANCE

The Renaissance, a period lasting from the fourteenth to the seventeenth centuries, saw a turning point in the history of portraits of all kinds, as realism returned to art. The artists Leonardo da Vinci, Michelangelo and Raphael, all made their mark during this period. Paintings and sculptures retained their value and to own such pieces continued to give you status.

The Baroque period, which lasted from the sixteenth century to the early eighteenth century, saw Flemish artists like Anthony van Dyck (1599–1641) and Peter Paul Rubens (1577–1640) flourish as they painted opulent images of important individuals, commissioned to show their authority. Many group figure portraits were commissioned throughout this period too, especially in the Netherlands; and Rembrandt Harmenszoon van Rijn (1606–1699) was constantly in demand to paint these types of portraits. Rembrandt often used pen and ink along with toned paper and sanguine pencil to draw action figures and sketches of posed models.

The first British painters to have had a major role in the progression of portraiture were Thomas Gainsborough (1727–1788) and Sir Joshua Reynolds (1723–1792). These artists specialised in producing portraits where their subject was captured in an eye-catching fashion. The use of assistants to help complete a portrait was where these artists differed. Gainsborough would rarely use an assistant, whereas Reynolds would sometimes only complete around a fifth of the painting himself.

Perhaps surprisingly, in the great portrait artist studios, the master himself usually created only the head and hands, while his apprentices would complete the clothing on the sitter. There were even specialist artists like Joseph Van Aken (1699–1749), who was brought in to paint more elaborate clothing and backgrounds on another artist's portrait. Peter Toms, who worked as a specialist drapery painter for Sir Joshua Reynolds (see above), went on to become a prolific figure painter in his own right, particular famed for his portraits of children.

Even with all the help and planning available to artists back then, there was still a chance of failure. The Neoclassical French painter Jacques-Louis David (1748–1825) was commissioned to paint the celebrated portrait of Madame Recamier. The result was not appreciated by the sitter and subsequently rejected!

The American portraitist Gilbert Stuart (1755–1828) found himself in a similar situation to David when a client was dissatisfied with the

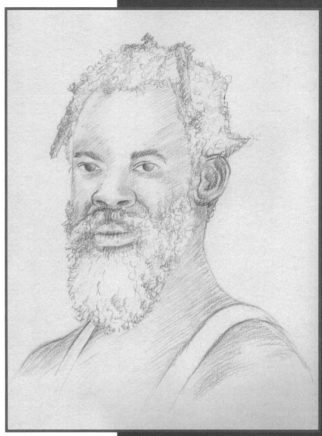

Man in the style of Cezanne
20.5 x 31cm (8 x 12in), graphite pencil on smooth white card.

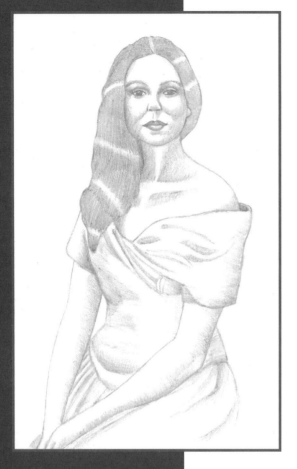

Long-haired woman in the style of Tamara de Lempicka

13 x 21cm (5 x 8¼in)

Graphite pencil on smooth white card.

commissioned figure painting of his wife. Upon hearing the husband's complaints, Stuart was heard to have replied with 'You brought me a potato and you expect a peach!'

Another portrait artist, important for adding humour to his paintings, was William Hogarth (1697–1764) who made a self-portrait including his pet dog called *Painter and his Pug.* Another particular favourite of mine is the painting entitled *Peter Darnell Muilman, Charles Crokatt and William Keable in a Landscape,* a group of figures painted by Gainsborough.

In the eighteenth century the typical time for completion of a full figure portrait was somewhere in the region of a year from start to delivery. Several sittings were required for most portraiture but some artists demanded more or fewer. The artist Francisco Goya (1746–1828), for example, preferred one very long day of sitting, whereas Paul Cézanne (1839–1906) insisted on well over a hundred sittings from each of his subjects.

Reynolds preferred to show his sitter a selection of drawings of them from which they would choose their favourite pose for him to paint. The style of his portraits was fairly similar in that the subject would sit or stand with a side view of their face and smiling was definitely discouraged. Some of Reynold's portraits contain backgrounds while others do not, but a common feature is that the sitters are dressed in formal finery. Portraits remained an important social statement.

By 1761 the aristocracy were paying Reynolds around sixty guineas for a full-length portrait and by 1764 the cost had risen to one hundred guineas – a huge amount of money. The price of figure portraits would ensure that only the landed gentry and upper classes would continue to have access to such a luxury for some time to come.

POPULAR PORTRAITURE

In the nineteenth century, painting entered the Neoclassical era and the tradition continued for artists to depict their subjects in the latest fashions. Romantic artists such as Eugène Delacroix (1798–1863) and Théodore Géricault (1791–1824) painted many beautiful figure portraits of inspiring leaders and striking women using drama created through quick brush strokes and mood-enhancing lighting.

This period saw a definite change of direction in figure painting, with some artists moving from commercial painting of the gentry or noble subjects towards subjects purely for study or pleasure. Géricault in particular is known for his daring style and some of the imagery was quite shocking and thought-provoking for this particular era. For example, he painted a series of ten portrait studies (of which five survive today) of mentally ill people after befriending two French doctors. His work was highly detailed, encompassing many paintings of subjects with complicated

backgrounds. The artists of this period also created realistic portraits of the lower and middle classes. Henri de Toulouse-Lautrec (1864–1901) captured many famous theatre performers while Edouard Manet's work hovered between realism and Impressionism. Edgar Degas (1834–1917) was also a Realist and one of his cleverest works depicted a painting of an unhappy family called *Portrait of the Bellelli Family*.

The nineteenth century saw the development of Conté crayons, which are sticks of wax, oil and pigment, combined with specially formulated paper. Endorsed by the French Salon, these quickly proved popular among figure artists; through the Salon forbade erasing mistakes – the artist was expected to draw the figure using pale strokes before making denser, more visible marks to finish their work.

At the close of the nineteenth century, the Impressionist movement produced artists like Claude Monet (1840–1926) and Pierre-Auguste Renoir (1841–1919), who began to experiment with breaking the rules of academic painting, producing beautiful portraits of individuals and groups. Post-impressionist artists such as Paul Gauguin (1848–1909) and Vincent Van Gogh (1853–1890) continued to develop this approach, producing portraits painted in a flurry of colour.

Experimentation continued in the twentieth century. In the early years, Henri Matisse (1869–1954) produced portraits using unnatural colours for skin tones, while Cézanne simplified his portraits by avoiding detail. Pablo Picasso (1881–1973) painted many portraits including cubist renditions of his mistresses. After the Expressionist period, artists like Francis Picabia (1879–1953) and Tamara de Lempicka (1898–1980) introduced contemporary themes like Art Deco to produce stylised portraits; a thread that later led to Andy Warhol's famed *Marilyn Diptych*.

During the mid- to late twentieth century, a significant contribution was made to figure portraiture by many Russian artists, but elsewhere there was a decline in portrait production. A revival in portrait and figure painting, starting with artists such as Lucien Freud (1922–2011) and Francis Bacon (1909–1992), who both produced powerful (if not particularly flattering) paintings, continues to this day. David Hockney (1937–) is a living example of a portrait painter who began making his mark in lots of styles of paintings and drawings, and who went on to produce some very influential portraits at several points in his career.

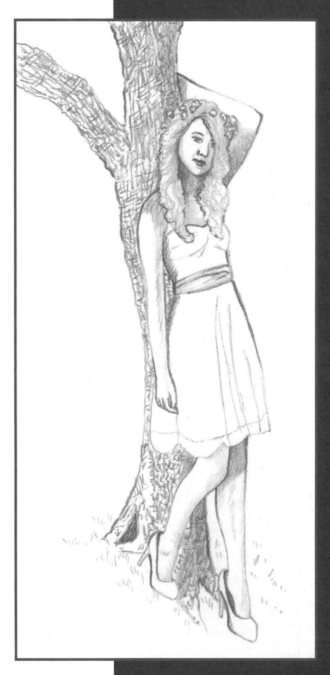

Girl leaning on tree in the style of David Hockney
12 x 21cm (4¾ x 8¼in)
Graphite pencil on smooth white card.

Materials

The medium you use to draw your clothed figures will come down to personal preference. I will show some of the most common tools and a few favourites of mine over the following pages.

Any pencil or pen has the benefit of immediacy. Drawing from life can often require a spur of the moment decision to sketch a particular scenario, so the fact that you can begin a drawing with next to no planning or pre-organisation is very appealing. Pencils and pens are also discreet, for those times when you want to capture a moment without drawing attention to yourself.

A selection of graphite pencils.

GRAPHITE PENCILS

Graphite pencils are something we have all grown up using and most of us are comfortable using one. There are quite a few different types of graphite pencil and countless different manufacturers. Which ones you use will come down to personal preference. The only way to decide is to try out a few different ranges to see which you like best.

Traditional graphite pencils are available in ranges for sketching and also for technical or architectural drawing. The main difference between these are that the technical type will give you a more distinct hard line and are not so easily blended, whereas sketching pencils are softer and more easily blended using your fingers or specialist blending tools.

Most pencils are available in a range of hardness from 9H (the hardest) through to 9B (the softest), with HB in the middle. Once you get to a 4B pencil you will start to find that you can lose detail, because the higher the number, the softer your pencil marks will be.

Woodless pencils have no wood mixed in their graphite, which means they are generally much softer than traditional pencils, whatever number you are using. They are a lovely medium to use if you want to blend your pencil marks and will give a looser finish in comparison to traditional pencils. Putty erasers and normal erasers (including battery-operated erasers) work very well with graphite pencils in general.

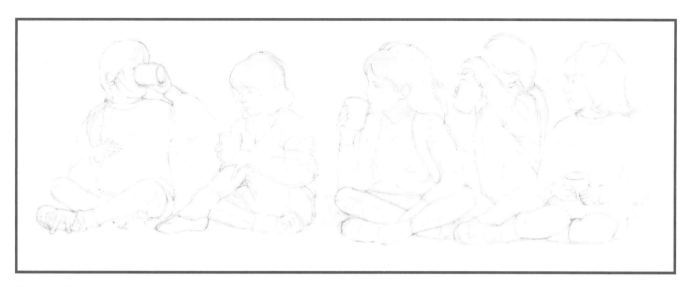

Sports Day

This sketch was completed using a 2H pencil as a simple line drawing. Graphite pencils lend themselves to capturing mood and position quite simply without any shading required.

Young Girl

Using a 2H pencil I sketched a basic outline of the girl making sure I had the proportion and expression correct. I then added more depth to the sketch by darkening it with a sharp 2B pencil.

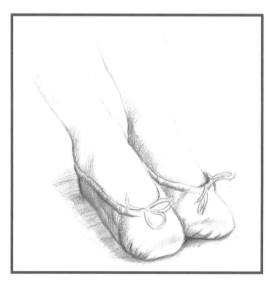

Ballet Shoes

This drawing shows how to use graphite pencils to create basic form and shape with light shading. I used a 2H pencil to sketch out the initial rough outline, then used a 2B pencil to shade the shoes and legs to produce a more three-dimensional image, rather than a simple line sketch like before.

Pastel pencils.

Soft pastel sticks.

PASTELS AND PASTEL PENCILS

Pastels are easily blended and work well on varying surfaces. Like graphite pencils there are different types, including pastel pencils and stick pastels. The particular sort you choose will be down to your own personal preference – try out a few to find your favourite.

Stick pastels come in soft, hard and oil varieties, and they all look very different. Hard pastels can be scratchy on the surface of your paper and are hard to blend if they are cheaply made. Prices range hugely, with top-range sets of pastels being very expensive. I recommend purchasing individual pastels and gradually building up a collection.

When buying pastel pencils, look for a range that blends well and sharpens easily, as these are marks of good quality. Cretacolor has a great colour selection and is excellent if you wish to experiment with pastel pencils, while Faber Castell Pitt Pastels and Derwent are my preference because they both have fabulous ranges of greys and blacks from which to choose – perfect for black and white artwork. Faber Castell Pitt Pastels pencils feel a little creamier and are a little more expensive than Derwent's range.

The only drawback (pardon the pun!) with the Derwent range is that the pencils are thicker than normal pencils and can only be sharpened by their specially produced pastel pencil sharpeners or a knife. If you do not feel comfortable sharpening with a knife, then I suggest choosing pastel pencils that can be sharpened easily with a normal pencil sharpener.

Man with Dreadlocks
This sketch was created on a tinted smooth paper, with a dark grey pastel for the main drawing and a white pastel for the highlights. These sort of sketches can be very satisfying and quick to complete. No real detail has been added yet there is enough information to create a story.

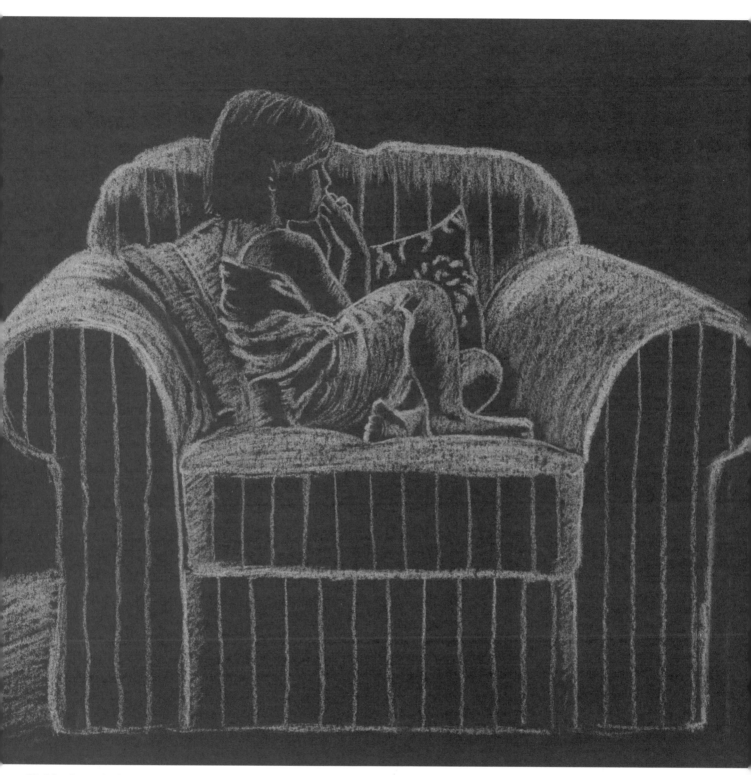

Girl in Armchair

This image shows a young girl looking very small in a huge armchair. I particularly liked the lighting, which has been recreated using a white pastel pencil on smooth black card. This approach meant I was really able to make the light the focus; highlighting where it falls on the figure and the chair to the greatest degree. It made me focus on the light only and leave the black card to fill in the rest of her form and that of the chair.

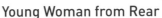

CARBON AND CHARCOAL PENCILS

These types of pencils are great for producing darker or stronger tonal drawings than graphite pencils. If you need to produce really dark blacks within your drawings of clothed figures, then these media – particularly charcoal pencils – are well-suited.

You can use carbon and charcoal pencils to fill in solid areas much more quickly than with graphite as they are even softer. As a result, more sharpening will be required as you work, though fortunately these pencils respond well to the normal type of pencil sharpeners.

Being so soft, these pencils blend very easily but are more prone to smudging than graphite, so you will have to be more vigilant with any loose particles falling away as you work. Charcoal pencils can be especially messy, but are regularly used in tight portrait work either on their own or in conjunction with graphite pencils.

You can create sweeping lines with carbon or charcoal pencils just as you can with graphite, but in an even looser format. However, if you are looking to create clean, sharp and detailed drawings you will need to use a very refined technique.

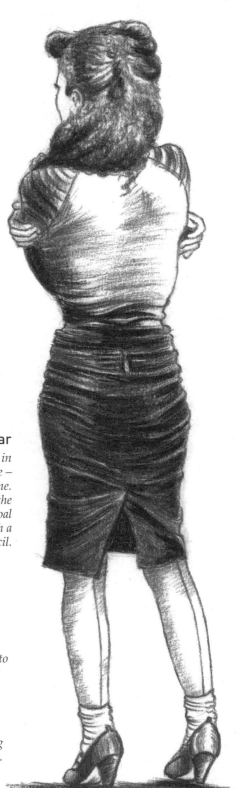

Young Woman from Rear

This is a drawing of a young woman in a pose showing her mood to be tense – perhaps searching the crowd for someone. It was completed in charcoal pencils: the initial lines established with 2H charcoal pencil and then depth was added with a 2B charcoal pencil.

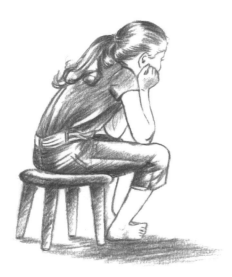

Girl Sitting on Stool

This drawing was sketched very simply with a 2H graphite pencil to enable me to be positive I had the proportions correct before I added more detail. I then used a sharp HB charcoal pencil to create a darker outline and shade the figure and stool, to add a more three-dimensional effect to the overall finish. Quick, strong tone is an advantage of charcoal pencils.

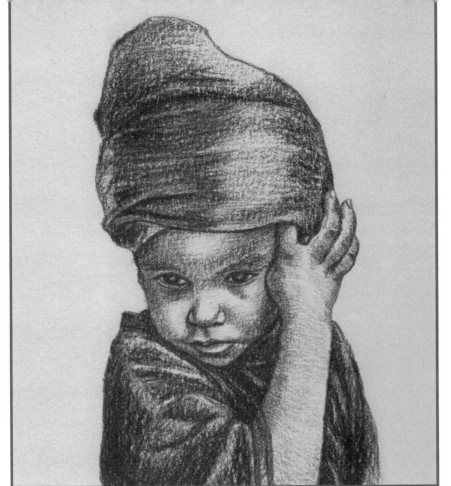

Boy with Turban

This drawing was sketched lightly with a 2H graphite pencil and then initially shaded with a B carbon pencil. The shadows were subsequently darkened further with a 4B carbon pencil, and a 6B carbon pencil for the deepest blacks.

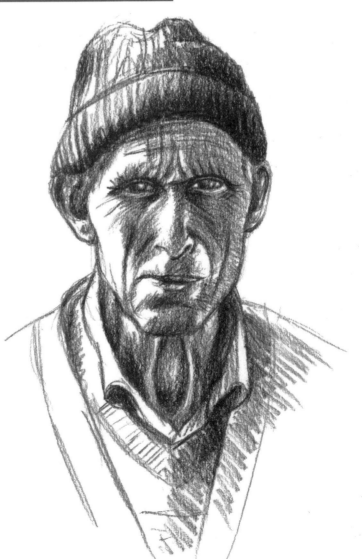

Old Man with Woolly Hat

A quick drawing produced solely using carbon pencils. I completed the most of the drawing with a B carbon pencil and then used a 4B carbon pencil for the darkest sections.

17

PENS

The following information applies to whatever type of pen you use for drawing. Before you put pen to paper, check to make sure you know where your pen mark or line is heading, so you can be confident with each stroke you make. Keep some rough paper under your hand as you work to minimise the risk of smudging. Above all else – enjoy!

As with pencils there is a large variety of pens you can use to sketch and draw. If you want to create a detailed drawing with fine lines, a technical pen is a good choice. They come in different point sizes which determine how thick your lines will be as you work. Mistakes can not be erased as these are a permanent medium, but if you want your construction lines to show and do not mind any errors being on display, these pens can create fantastic work for you. The downside is that it may be hard to get your lines to properly sweep and curve if you are covering large areas, as you will be restricted by the nib size and flow of ink.

Two technical pens (top) and two fine-tipped ballpoint pens (bottom).

If you are working on a larger format then a ballpoint pen may be the best option for you instead. You can really create long curved lines with one continuous sweep of your wrist or arm and they work well on many surfaces including textured ones. I fell in love with ballpoint pen back in my art college days as we were regularly encouraged to use it for life drawing classes. The main thing to have to be aware of is that it is not a very forgiving medium and any errors could be glaringly obvious.

You can also use pens in conjunction with coloured media like water-soluble pencils, watercolour paints or pastels, though this requires you to test the materials beforehand on scrap paper. For example, ballpoint pens do not apply well over coloured pencil work due to the pencil's waxy coating.

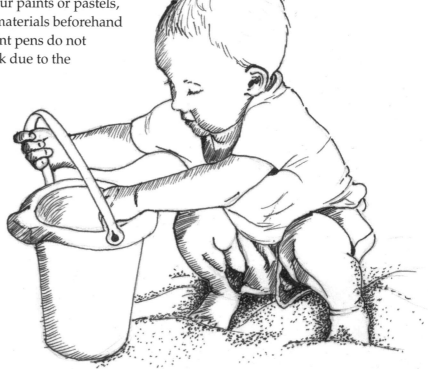

Toddler on Beach

A quick sketch produced using a technical ink pen with a nib size of 0.35mm (¹⁄₆₄in). I have added a little bit of shading with lines for shadow and dots to replicate sand around his feet.

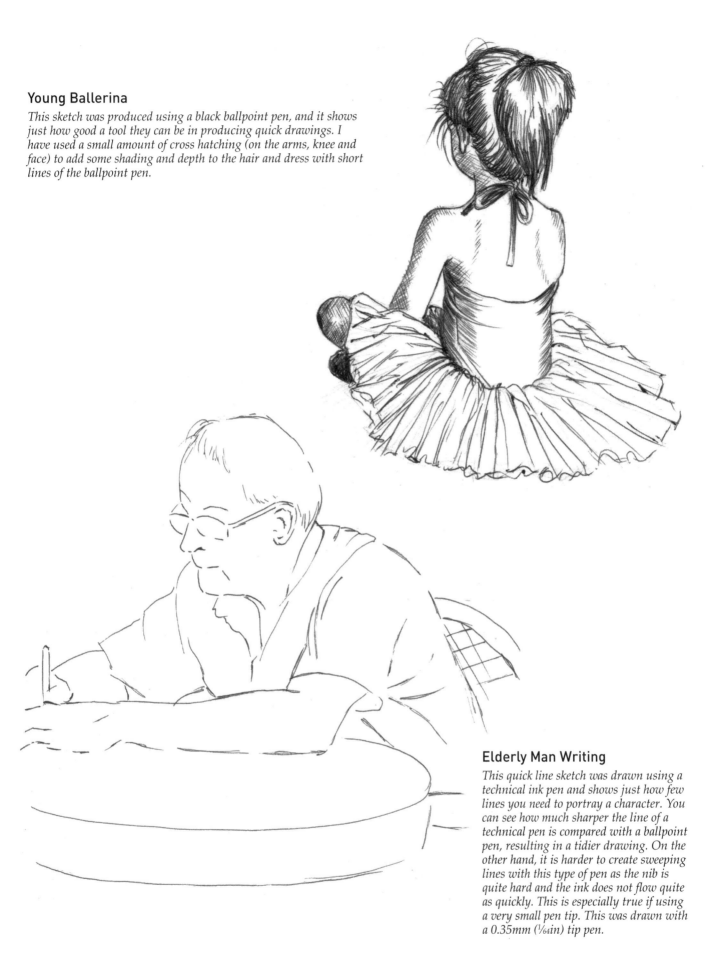

Young Ballerina

This sketch was produced using a black ballpoint pen, and it shows just how good a tool they can be in producing quick drawings. I have used a small amount of cross hatching (on the arms, knee and face) to add some shading and depth to the hair and dress with short lines of the ballpoint pen.

Elderly Man Writing

This quick line sketch was drawn using a technical ink pen and shows just how few lines you need to portray a character. You can see how much sharper the line of a technical pen is compared with a ballpoint pen, resulting in a tidier drawing. On the other hand, it is harder to create sweeping lines with this type of pen as the nib is quite hard and the ink does not flow quite as quickly. This is especially true if using a very small pen tip. This was drawn with a 0.35mm (¹⁄₆₄in) tip pen.

19

OTHER MATERIALS

In addition to the drawing medium and surface you use, you will need a few other items. They can be purchased from most good stationers.

Correction pen A fine-tipped correction pen allows you to correct mistakes in very small areas of your drawing. Allow any mistakes in your pen work to dry before using this pen to correct it or you could end up with a black smudge instead.

Mouse This correction implement applies dry correction tape – ideal for amending larger areas where the correction pen would be impractical.

Masking tape This tape is used to fix your surface paper or card to your work surface to prevent movement whilst you are drawing or shading.

Drawing board Any flat rigid substance to which you can affix your surface paper – such as art board, MDF or a hard canvas – can serve as a drawing board. This will enable you to work at an angle rather than flat which will help you avoid distorting the perspective and proportion of your clothed figures as you draw.

Plastic eraser A simple eraser can be used for removing pencil marks over large areas, or to simply remove unwanted pencil lines.

Putty eraser A soft eraser that can be shaped to erase small areas of pencil or lift off excess graphite in shaded areas of your drawing.

Rough paper To prevent smudging your work, rest the side of your working hand on a clean piece of scrap paper as you draw.

Pencil sharpener A plastic or metal sharpening tool to sharpen graphite, carbon, charcoal and pastel pencils to a fine tip.

Blending torchon A pen-shaped soft blending tool used to blend pencil and pastel marks into smooth unlined areas within a drawing.

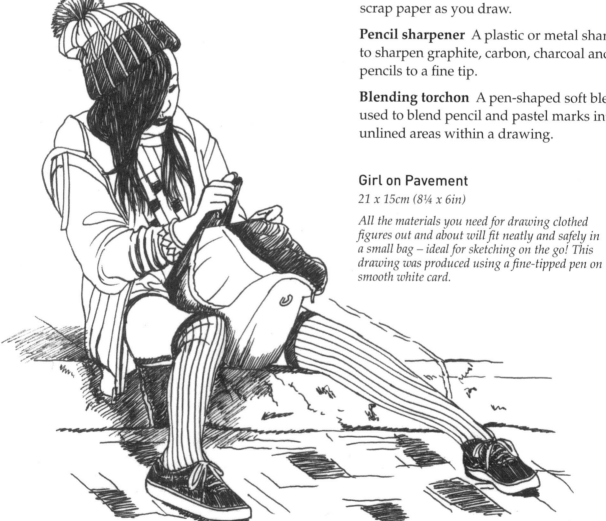

Girl on Pavement
21 x 15cm (8¼ x 6in)

All the materials you need for drawing clothed figures out and about will fit neatly and safely in a small bag – ideal for sketching on the go! This drawing was produced using a fine-tipped pen on smooth white card.

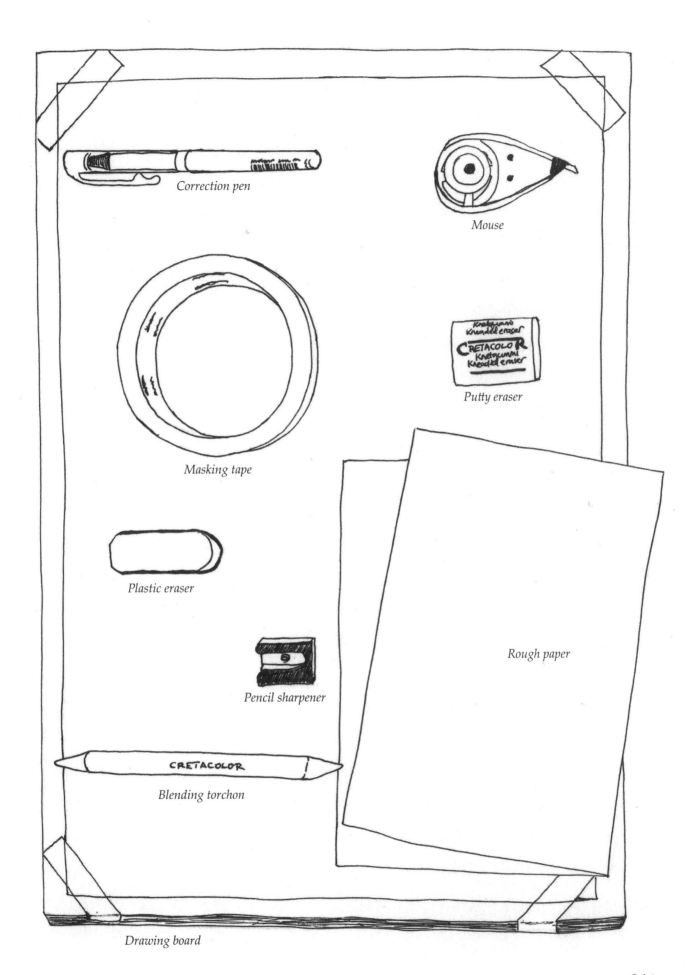

Correction pen

Mouse

Putty eraser

Masking tape

Plastic eraser

Rough paper

CRETACOLOR

Pencil sharpener

Blending torchon

Drawing board

SURFACES

There are many surfaces from which to choose for your clothed figure drawings. The type you use depends on the finish you want to achieve.

Paper and card

I typically favour smooth card for my drawing surface as it suits my method of working, which is photorealistic. Smooth card or hot-pressed paper surfaces give a clean result, with the only texture being that which I have created within the subject. If your technique is loose and flowing, you may prefer to use a watercolour paper with a slight texture, such as Not surface (short for not hot-pressed) or rough surface. Watercolour paper is available in a number of different weights and textures. The best way to decide what works for you is to acquire a few samples and simply try them out by doing a few sketches along with some solid shading so you can see how the surface reacts.

There are other boards you can use to work on, such as mount board, which has a fairly smooth surface, and various types of cartridge papers manufactured purely for drawing upon.

A variety of drawing surfaces.

Canvas

Using a textured surface can have a huge impact on your finished drawing. Canvas is usually associated with painting and is not an obvious option for pencil drawing. However, graphite pencils work very well on this heavily textured surface – particularly graphite sticks, as they tend to be softer and adhere better to it. Although I usually opt for smooth boards, when I have used graphite on canvas I have been very pleased with the results.

Canvas is not forgiving of mistakes – using an eraser on canvas will only result in a big smudge, so you will have to ensure you get your outline right first time around. The best way to do this is to trace the outline onto the canvas to make the process easier. Once you have done this you are ready to begin shading your subject.

The main difference between canvas and smooth paper or card is that strong darks are harder to produce on the textured surface. You can use charcoal or carbon pencils for strong darks on canvas, but the finished drawing will need to be protected due to the likelihood of smudging.

Textured surfaces suitable for pastels

The types of surfaces suitable for pastel sticks or pencils are quite varied and can include smooth mount boards, velour, watercolour papers, and even canvases but mainly if you are using oil pastels.

There are also specialist pastel papers available which have a surface that could almost be described as 'fluffy'. You can create lovely textured drawings or sketches using these speciality types of papers because they have been created specifically for pastel work. They are not too forgiving when it comes to correcting errors as you can quite easily damage the delicate surface.

Brothers
21 x 29.75cm (8¼ x 11¾in)

Carbon pencils on Not surface watercolour paper.

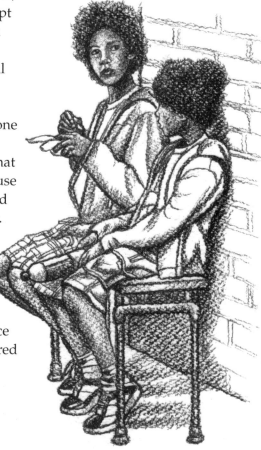

Tinted surfaces

Darker surfaces can give striking effects, though you will have to modify your medium to suit darker grey or black paper or card. In general charcoal sticks or pencils can look great on grey backgrounds for loose sketches of people but obviously the tint of the card or paper will have to be fairly light for the charcoal effects not to be lost.

There is a really good selection of greys or black in smooth papers and cards available. I use those from Canford and Clairefontaine Maya regularly. There are also some beautiful textured pastel papers with tinted surfaces which work just as well with carbon pencils and white Conté pencils.

Other media which work well on grey tinted smooth cards or papers are pastel pencils, coloured pencils, ballpoint pen and ink pens.

Natalie and Lauren
51 x 40.5cm (20 x 16in)
Pastel pencils on smooth light grey card.

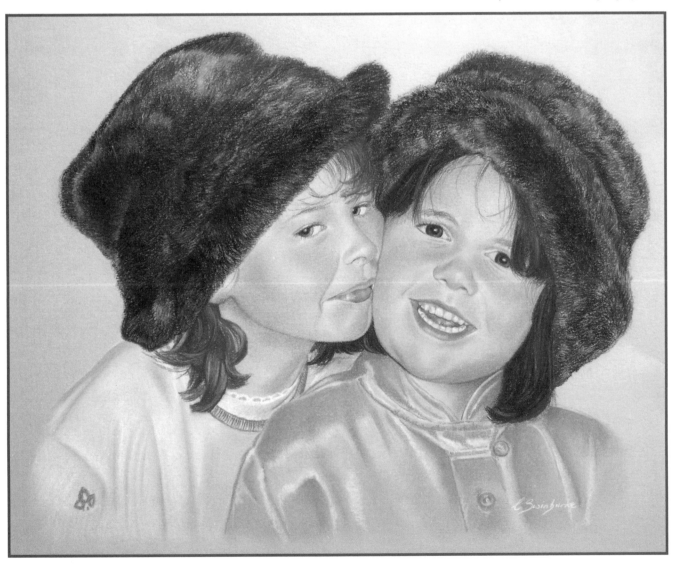

How to start

The images on the following pages show the sequence of work, beginning from gathering your reference right through to the finished drawing.

WORKING WITH PHOTOGRAPHS

Gathering photographs

If you are drawing solely from photographs then your pictures have to be extensive and good quality. Ideally they should be lit in the same way, and you should take them from many different angles to help you build up an almost three-dimensional image of your subject.

It is important that you have all the visual information you need, as you will not have the model in front of you for reference. Think about all the details that you will need. Ears in particular can be difficult to draw from certain angles, so the more detailed images you have to work from, the better. Similarly, close-up shots of eyes and other facial features are imperative for accuracy.

If you later find that you do not have a close-up shot of a particular feature you need – such as the sitter's ears, for example – ask a close friend if you can have a good look at the structure of theirs. Most people's features have a similar basic structure. If they do not mind, take some additional photographs to help you.

A final important point: if possible, do ask permission to take photographs to avoid making people uncomfortable. Not everyone will be keen to be your subject!

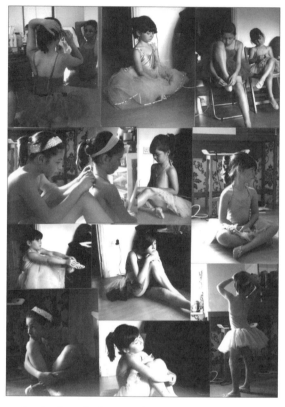

A selection of reference photographs for this example drawing, from which I will select a final photograph.

Making decisions

There are a lot of considerations to take into account before you make the final choice of which photograph to use as your final reference image, but do not worry if the image is not perfectly shot. There are many ways of improving an image if the lighting or crop is not exactly right, which I explain later.

To help decide on which photograph from the selection to use, ask yourself a few questions about each image. What is the lighting like – can you see everything you need, or is it too dark? Are the face or limbs hidden or at a strange angle and difficult to draw? Can you see the whole figure or are important parts obscured? Is there any unwanted foreshortening of arms or legs? Is the subject sitting or standing in an attractive position?

Most of these issues can be overcome if they are not marked in the photograph, but do be honest. Sometimes it is better to pick a different photograph than struggle through trying to fix a multitude of problems.

Choosing a final photograph

For the purpose of showing you how to develop a drawing from your picture, I have selected the image to the right from the selection of reference photographs opposite. I chose this image owing to the little girl's position, sitting cross-legged on the floor. The quietness and poise gives the composition an attractive quality and shows the sitter's character well.

Looking over the image to check my choice will work, I confirm that the subject is well-lit – in this case, the light source is coming from the rear which lights up the back of the girl and throws the front of her body into soft shadow. I really like the way the skirt of the tutu is highlighted behind her and the way the light is falling on her shoulders and right knee.

Although the front of the figure is in shadow, the shadows are not too dark so her face is still easily discernible and will be easy to draw from. The background is very busy, but as that will not be reproduced in my drawing, it will not be a problem.

The cast shadows are also soft and will be easy to replicate. I can also easily work out the relation between all of her limbs in her seated position as nothing is obscured.

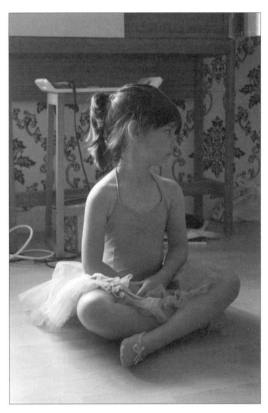

The selected final photograph.

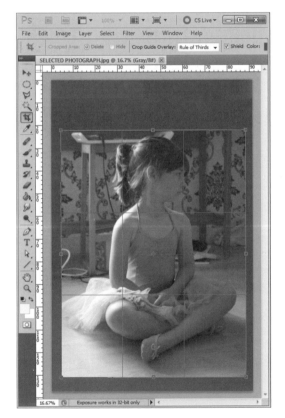

This image illustrates how I have used the Crop tool to remove unwanted foreground and background detail. Around the outside edges of your image a dotted white line will appear, on which you can click and adjust to crop out extraneous background detail.

Improving the photograph

The best thing about being an artist is the realisation that you can always improve on the photograph, so being an amateur photographer is not an issue. That said, there's no need to make your life harder than it needs to be, so making some small alterations to ensure you have a clear and light photograph from which to work is a good idea.

I mentioned that the background in my chosen image is a little distracting and unnecessary and I always crop out any unnecessary background, to help me concentrate solely on the subject when I am drawing it out. This can be done physically using a pair of scissors to cut away distracting excess parts of the photograph, but most computers come with their own built-in basic editing software nowadays and it is very easy to crop and rotate your image if required. Cropping allows you to experiment with different compositions and helps remove unnecessary details from the background.

If I am using a computer, I will also always look at the lighting and use software to add a little more light if I am struggling to see facial details. In some cases I will sharpen the image if it is required. When all the alterations have been made, I will save this image as a different version so I still have the original to work from with the original lighting.

YOUR FIRST DRAWING

Having selected the final photograph and gathered all the relevant reference images together, you need to decide on the medium to use and the paper or card you are going to draw it on. Once this is established, you will no doubt be wondering just how big your drawing surface should be. I would never begin to draw a full body composition like this picture of a young ballerina on anything smaller than a 29.7cm x 42cm (11¾ x 16½in) size sheet of paper or card. If you have a large drawing board or desk and want to be more adventurous, then piece measuring 42 x 59.4cm (16½ x 23⅜in) is perfectly acceptable.

Preparing your workstation

Set up your work area where you are not going to be disturbed and ideally where you can put down your tools and leave them for a while without having to pack up every time you take a break. Ensure that you are near a table where you can lay out all of your materials and have them close to hand. You do not want to have to keep getting up every five minutes to retreive an eraser or pencil sharpener once you are in a comfortable drawing position.

Secure your paper or card surface in position on your drawing board using masking tape at the corners. If you have an easel or art desk, you can simply put the board in place and begin. If you do not own an angled easel, sit at a table and rest the bottom edge of your drawing board on your lap. Working at a slight angle helps you to judge the proportions in your drawing far more easily than working completely flat, so lean the canvas back against the edge of the table at a comfortable angle.

Transferring the image to paper

If you are working from photographs, you have a few choices of how to transfer the image to paper quickly. The simplest methods are tracing, using a projector, using the grid method, or photocopying the outline onto your surface – though note this last method will only work if your drawing surface is no heavier than 200gsm (120lb) or so.

Alternatively, you can of course draw your outline freehand. This may take longer and involve more corrective work than the other methods above, but the end result will be immensely satisfying.

Measuring by eye and pencil

A good method for transferring your image onto your surface freehand is measuring by eye. This technique is traditionally used for life drawing but can be adapted to drawing from two-dimensional images. A natural ability when it comes to judging proportion is obviously helpful, but this technique will help you end up with a fairly balanced drawing regardless of your inherent level of skill.

This drawing method centres around using your eye and your pencil as a measuring tool, which help you place marks on the paper that you can build your outline from. It is almost like drawing a dot-to-dot outline but you can make your marks bigger and bolder than mere dots as you gain in confidence.

This technique relies on you laying the pencil on the photograph (or other source material) to copy the angle and then placing the pencil at the same angle on your paper to transfer the line correctly. See the diagrams below, which illustrate this. The technique can be tricky at first as you need to ensure you can keep the pencil at the desired angle while using the tip to draw the line. Practice will ensure you get better at this technique and it will prove invaluable as you begin sketching from your own reference material, whether photographic or from life.

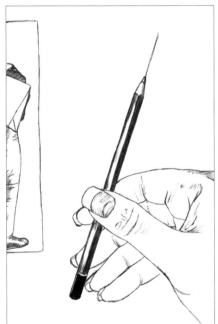

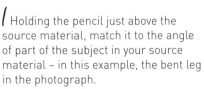

1 Holding the pencil just above the source material, match it to the angle of part of the subject in your source material – in this example, the bent leg in the photograph.

2 Holding your pencil at the same angle, carefully move your hand sideways to the blank drawing surface. Gently tip the point of the pencil downwards and make a rough pencil mark at the same angle you are transferring. Go back to the photograph and continue to measure any other angles and then capture and transfer them in the same way.

First strokes

The drawing begins as a series of lines, and there is little or no detail required in these early stages of establishing the image. You need to make sure that you have understood the perspective and proportion correctly before taking your drawing to the next level. Some things you need to consider when sketching are:

- From your first mark to your last, keep checking that there will be enough room for the whole of your subject.

- Compare other features for useful measurements as you work. The distance between the corners of the eyes is often the same as the length of the nose, for example.

- Refer to your photographs as you work to keep mistakes to a minimum.

- Do not get too ahead of yourself by adding detail early on. It is soul destroying to have to rub out well-drawn sections because of an error with proportion.

- Take regular breaks so that you can continue to be objective and look with a fresh eye each time you return to your drawing.

The first marks you make with the pencil should be made with the lightest of pressure so that they can be erased if need be. Treat these initial stages as basic construction of the form of your subject and nothing else. Once you have a balanced sketch you can build on the detail.

Once you have established the size of the head is correct, continue to add the rest of the body. Use the depth of the head to measure the length and depth of other parts of the body. It is as simple as using your fingers to 'pinch' the measurement and transfer it, or you can use a ruler.

There is plenty of time for detail once you are certain the head is the right size compared with the shoulders, and that the limbs are the right length in relation to one another. This is especially important with regards to the position the subject is seated or standing in.

The first strokes applied to the surface. All you can see at this stage on my drawing are lots of lines at different angles representing the head and shoulders of the girl. This is a good way to start building up proportion. By keeping it simple you are prevented from adding detail too early.

Basic shapes and outline

With the first strokes in place, check that the size of the finished sketch is correct – i.e. that it will fit on the paper. From here, you can begin to fill in the shapes of the figure. My preferred place to start is the structure of the shoulders.

Using the pencil and eye measuring technique (see page 27), establish the line of the shoulders, then use this to work out where the neck begins, the angle the face slants away at and so forth. The more pieces you add, the more you have to use as a comparison as to where the next feature lies. At this point, add any shadows or lines on the face – quite harshly at first – to help plot where the nose and eyes should be.

With the shoulders in place, you are ready to draw the head. In this example, the width of the shoulders is almost equal to the depth of the head (from the top to the base of her throat) and this will help you draw the head in proportion. Look for similar points of comparison in your subject. Once the head is sketched in, it is easier to measure the angle of the ear in relation to the subject's nose and chin.

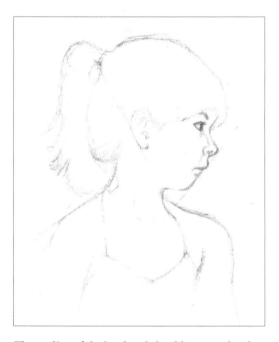

The outline of the head and shoulders completed. You can see the construction lines I have created to understand the angles of her features and the distances between them.

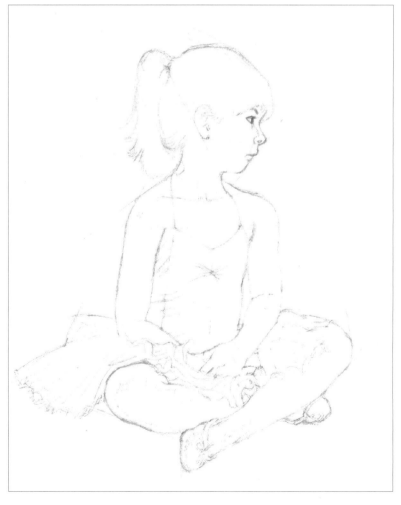

The completed outline. I prefer to get to the stage where I have a well-balanced head and top of body sketch before working down the drawing and adding the rest.

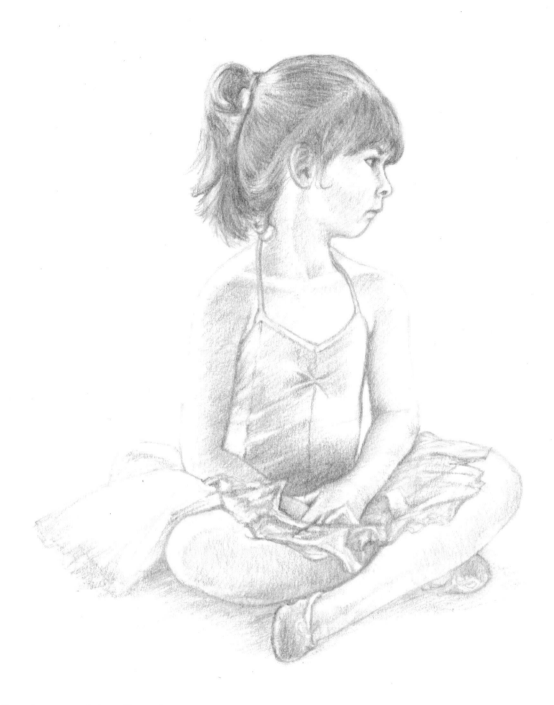

Adding tone and detail

When you have checked that your finished sketch has everything in the right place and all features and limbs are the right size and shape, you are ready to add some detail. Still working with a 2H pencil, gradually shade the hair and figure very gently using hardly any pressure. Use a putty eraser to lift off any hard pencil lines. Do this tentatively, in case you need to erase anything, and build up the detail slowly step by step.

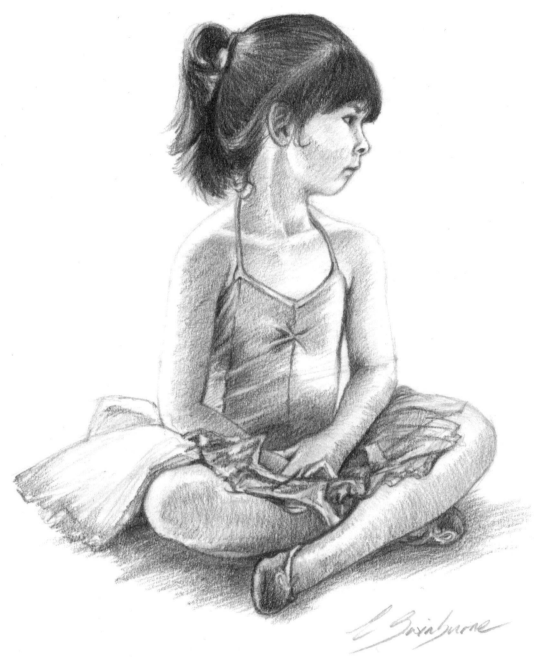

Completing the picture

To finish, work back over the figure again using a sharp 2B graphite pencil to darken the shading until the tonal values are correct, with deep shadows and light highlights.

The finished picture

15 x 21.5cm (6 x 8¼in)

Graphite pencil on smooth white card.

Proportions

Body proportions are key if you want to produce a realistic replication of your chosen figure or subject. If seeing proportions comes naturally to you, you are halfway there; but if you have always found it hard to understand this particular subject, this chapter will show you how to identify and achieve correct proportions in your drawing of clothed figures.

USING THE HEAD TO FIND PROPORTIONS OF THE BODY

When you first start to draw clothed figures, how do you know how to draw someone in proportion? The easiest way to do this is to use something to measure by – most commonly, the head, as with the drawing of the ballerina exercise earlier. Once the head is established, you can create the rest of the body in proportion to it. As a result, getting the size of the head correct in relation to the rest of the body is an important start when you are drawing the outline.

The diagram to the right shows four figures – an adult male, an adult female, and two children of different ages. Next to each is a scale ruler to help show how the size of the head relates to the rest of the body.

Both of the adults stand at around seven of their own heads tall. This is described as a proportion of '1:7'. Note that because the man has a larger head, he stands taller than the woman, though the head to body proportion of 1:7 is the same for both.

Children have larger heads relative to their height than an adult, and so you require fewer heads to get the height correct. For the older child, only six head depths were used to create this line drawing – a proportion of 1:6 – though the number of head heights will relate to the age of the child. As a general rule, the younger the child, the fewer heads in height they will stand. For the toddler on the far right, I have used a proportion of only 1:4.

You can also use the scale ruler to ensure you have the proportions correct. For example, the torso should be roughly the same length as the legs – both should measure approximately three heads in height for anyone other than a baby or toddler. If the legs are longer, or shorter, you can adjust your drawing.

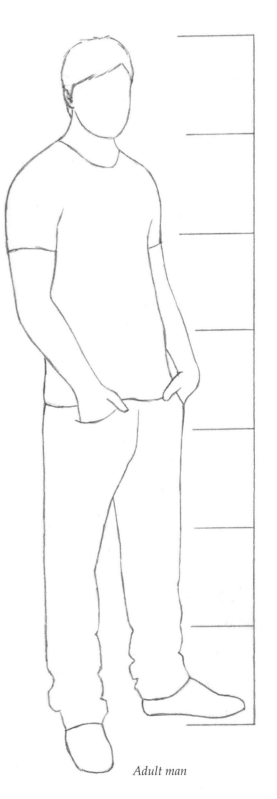

Adult man

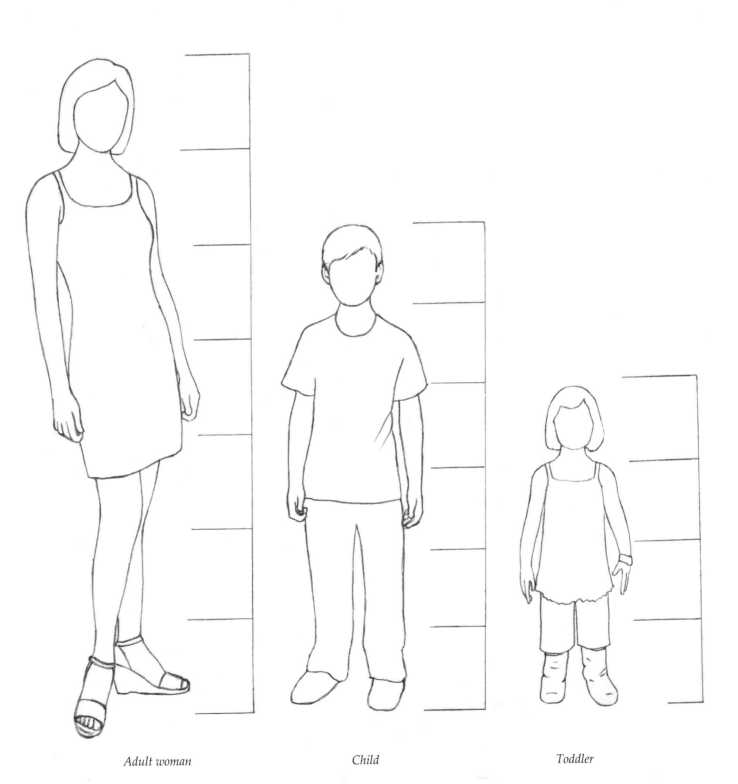

Adult woman *Child* *Toddler*

33

DIFFERENT POSITIONS

Understanding what happens to the body's proportions as it moves into different positions takes time to learn unless you have a natural flair. Limbs bent in a cross-legged pose, someone standing at an unusual angle, people lying down with arms or legs foreshortened – these are all challenging positions to recreate in a sketch or drawing. I have picked some fairly straightforward ones for us to start with here to explain the principles behind drawing these more complex shapes, so alongside each finished artwork are the basic lines to help show how you move from first strokes (see page 28) to completed artwork. I find the easiest way to begin to establish a structure and get a sense of proportion is to use the measuring by eye and pencil technique described on page 27.

Before you start have a good look at your reference picture to ensure you fully comprehend what is happening in the photograph and note the relationship between all the limbs.

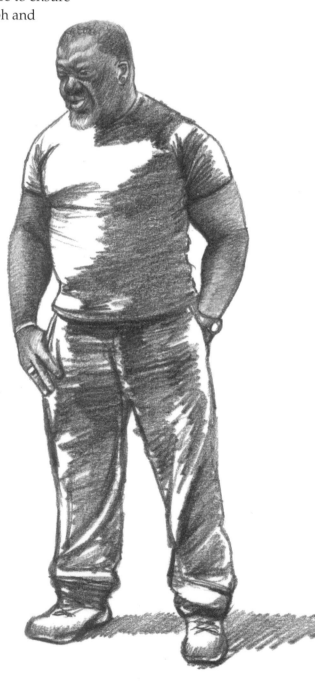

Standing Man

When I was out for the day in Camden Town in London, I saw two men standing together, one skinny and short, the other large and imposing. They looked comical together and I could not resist taking a photograph.

One subject is enough for this exercise, and I picked the larger of the two. As you can see from the structured basic line sketch (see above), I have concentrated on getting an idea of his height and general position by using the eye and pencil technique. As I worked from the basic sketch, I began to refine the correct proportion and position. For a simple pose like this, the sketch was enough to work from to produce the final drawing.

Crouching Girl

Capturing the proportions of this young girl on the beach is a little more complicated than the standing man opposite. Her legs are bent and you need to get the length of the leg from thigh to knee and from knee to ankle in proportion, which may prove difficult at first.

Start with a few lines depicting the general position of the head, then use the depth of the head (measuring from the back of the head to the bottom of the chin) to give you the deepest measurement of both her knees side by side. When checking your proportions, ensure that the knees do not stick out further than the head itself and check that both arms are long enough to show they are slightly bent and not completely straight.

Sitting Man

Camden Town has such a variety of ethnic backgrounds and loads of distinctive characters from which to choose. I loved all the folds in this man's clothing, and the casual pose which was slightly marred by his facial expression, which was far from relaxed.

His head shape and size are slightly different from the others shown on these pages because of the height of his hair. His backpack is also an important part of the composition, so this is added to the basic lines. To get the proportions of the legs correct, use the width of his chest to help you establish how far the bent knee should be away from his body (the one he is resting his arm upon). Similarly, the leg that is dangling should not be any longer than the depth of his torso (shoulder to bottom).

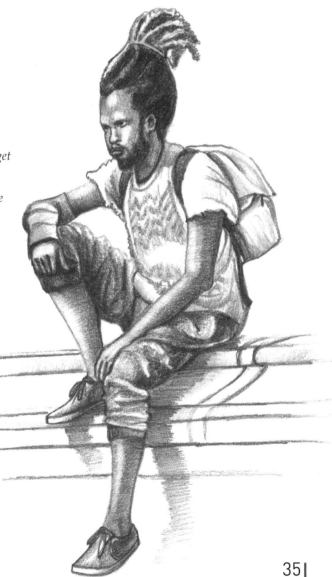

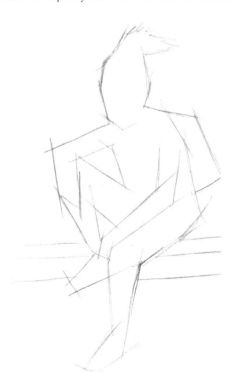

People Watching

This demonstration shows you how to apply the principles of proportion and pose explained on the previous pages. You have just learned about basic shapes and this is how you are going to begin this drawing.

Even though the pose of this seated man differs from the proportional drawing of a standing adult male (see page 32), this method can still help guide you towards the correct proportions in your drawing. For example, you can still use the method of measuring the depth of the head in the reference picture to see how many times it divides into the torso; and similarly for the lower legs. The same technique can be applied when drawing the hands. Comparing parts of the body against each other for size to keep the anatomy correctly in proportion is very helpful.

MATERIALS

Smooth white board, 29.7cm x 42cm (11¾ x 16½in)
2H and 2B graphite pencils
Putty eraser
Eraser
Pencil sharpener
Board and masking tape
Rough paper

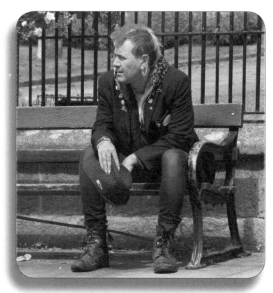

The source photograph used for this project.

1 The important thing to do at this point is complete a sketch of the figure's body using basic shapes to ensure the proportions are correct. Working in the centre of the board, use the 2H graphite pencil to build up simple lines to suggest the body's position before moving on to add the head. Keep your pencil lines quick and light and forget about adding any detail at this stage. Use your pencil to measure angles by resting it on the reference picture, capturing and holding that angle until you reach your paper.

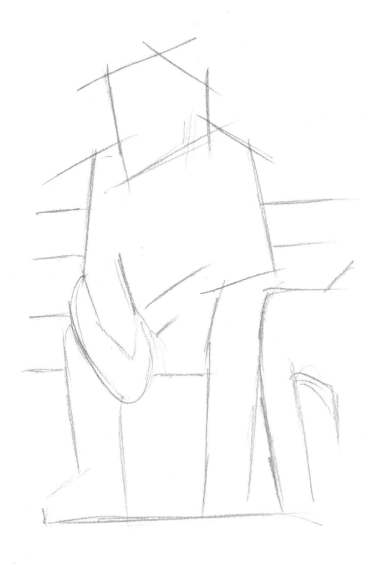

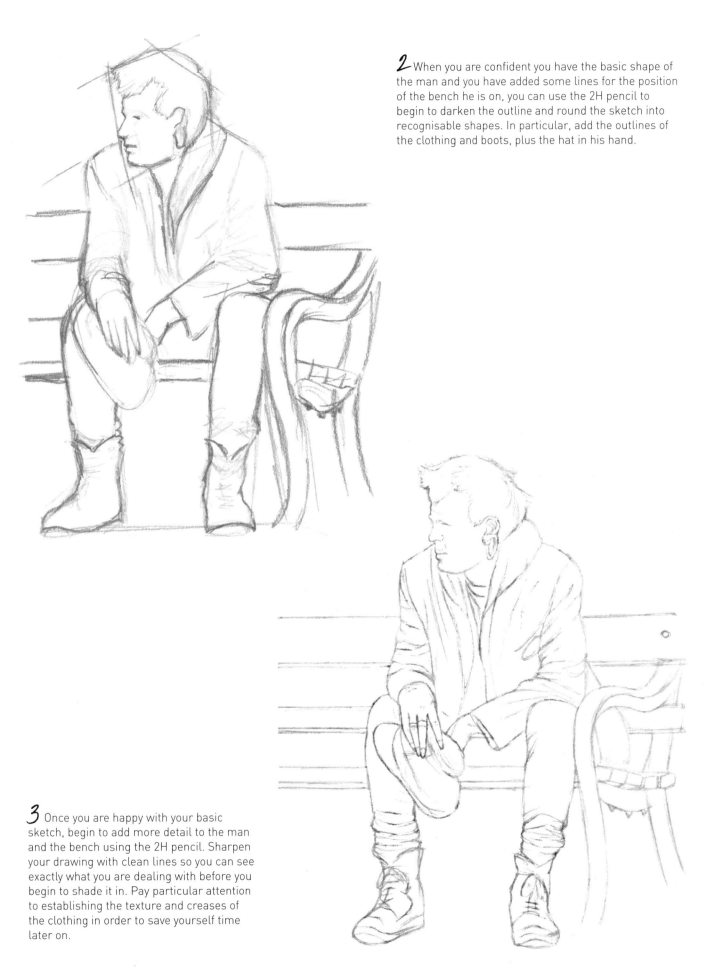

2 When you are confident you have the basic shape of the man and you have added some lines for the position of the bench he is on, you can use the 2H pencil to begin to darken the outline and round the sketch into recognisable shapes. In particular, add the outlines of the clothing and boots, plus the hat in his hand.

3 Once you are happy with your basic sketch, begin to add more detail to the man and the bench using the 2H pencil. Sharpen your drawing with clean lines so you can see exactly what you are dealing with before you begin to shade it in. Pay particular attention to establishing the texture and creases of the clothing in order to save yourself time later on.

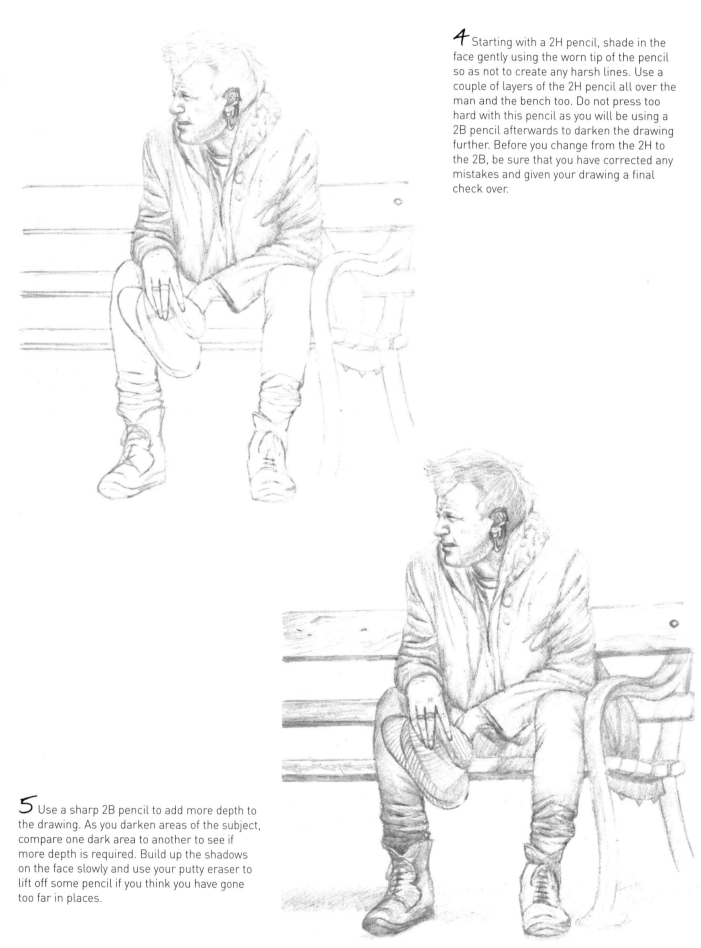

4 Starting with a 2H pencil, shade in the face gently using the worn tip of the pencil so as not to create any harsh lines. Use a couple of layers of the 2H pencil all over the man and the bench too. Do not press too hard with this pencil as you will be using a 2B pencil afterwards to darken the drawing further. Before you change from the 2H to the 2B, be sure that you have corrected any mistakes and given your drawing a final check over.

5 Use a sharp 2B pencil to add more depth to the drawing. As you darken areas of the subject, compare one dark area to another to see if more depth is required. Build up the shadows on the face slowly and use your putty eraser to lift off some pencil if you think you have gone too far in places.

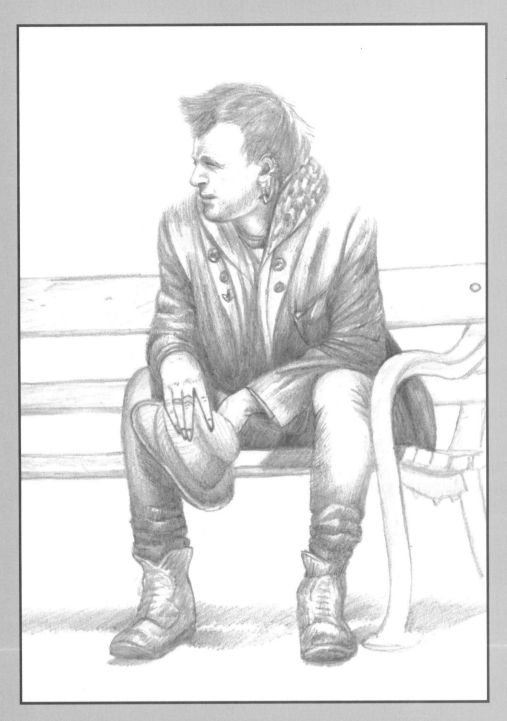

6 Add the final details and strengthen the tones in the figure using a sharp 2B pencil. Finally, darken the shadows on the bench and on the ground to complete the drawing.

The finished picture
15 x 21.5cm (6 x 8¼in)

Graphite pencil on smooth white card.

The human figure

Despite sharing some common features, people are fascinatingly different. The following chapter looks closely at some important details of drawing clothed figures.

HEADS

Drawing heads can be absolutely absorbing and the choice of subject matter is literally endless. The angle of the head, the age of the subject and their gender can have a huge bearing on images that you are naturally drawn towards. Similarly, how a person's head is dressed can add such fabulous detail to a subject that hats and head robes are really worth considering. In fact, you are very likely to have a particular type of subject in mind.

My advice is to discard this – keep your options open as you peruse images or take photographs out on the street, and try not to be be too single-minded about what you are looking for. Obviously, lighting and composition will play a huge part in your decision but really spend some time looking before you settle on your final image.

There should be enough information within your head portrait to give the viewer a good idea what position the rest of the body is in. For instance if your subject has a contented expression on their face, they are unlikely to be standing bolt upright with stiff arms and legs. Their attitude will be relaxed and their posture to match.

The head is such an important feature of a complete clothed figure, but if your drawing is of head and shoulders only, as with the examples on these pages, it becomes even more significant.

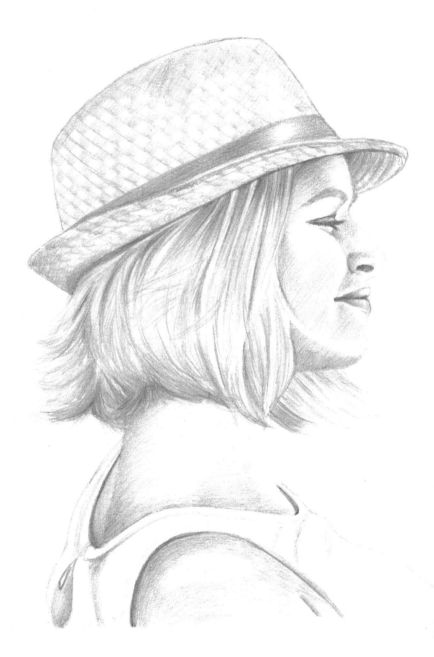

Smiling Girl in Hat
I used a 2H pencil to create this drawing as I wanted to keep the light feel to it. Harder pencils are very useful to keep tone light; useful for showing off this girl's blonde hair to full effect against the texture of her hat.

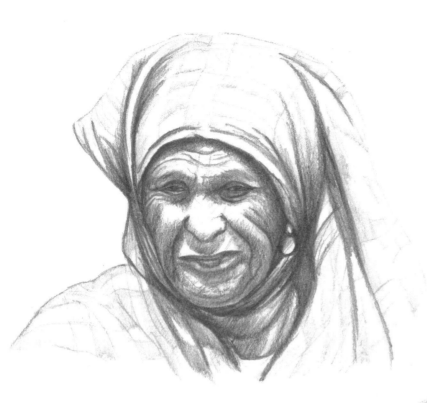

Berber Lady on Tinzouline Market

The depth of the creases in this woman's face are very pronounced due to strong sunlight, so depth of tone is important in describing the texture.

This captivating picture was created with a 2H pencil to build up the lines in her face and then a 2B pencil to darken the whole image further.

Soldier

For this image I used a 2H pencil for the first layer of pencil and then built up the character and depth in his face with a 2B pencil. Using less pressure than in the old woman above helped to keep him from looking too haggard, while still getting across the complex texture of his facial expression.

41

HAIR

As with the subject of heads, hair can offer such a diversity of choice it will be hard to make a decision on what you like best. The hair of your subject will usually be a big part of their individual look and will tell you a huge amount about them as a person. This can be very helpful in portraying the figure's character.

Visiting places where there are diverse groups of people with very specific ideas about their body image – both in terms of fashion and how confident they are in public – will give you food for thought and probably make choosing one final image very difficult. However, it will certainly open your mind to all the options available.

When you are creating hair, try and see the overall shape that the hair is making rather than trying to replicate each individual hair. Take a step back and look for the shapes, patterns and form within the hair as a whole and you will draw it in a much more realistic way.

The examples on these pages show how you do not 'read' individual hairs – just the shape of the mass in highlights and shade. The hairstyle and an odd strand or too of loose hair can help the viewer recognise what they are seeing.

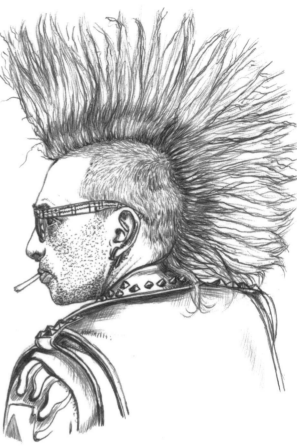

Man with Mohican and Cigarette

The man was holding an advertising sign outside the hairdressing shop that he worked for – cue another sneaky bit of photography! It took me a while to catch him in an interesting pose. I decided this picture would be best portrayed using black ballpoint pen, which let me capture the fine lines and intense texture of his hair and stubble.

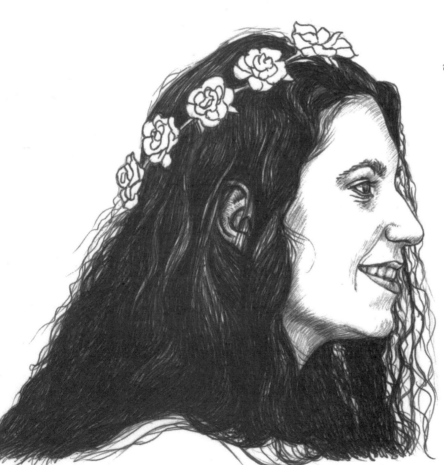

Dark-haired Girl with Head Garland

It was quite a challenge to get the correct depth of black for the mass of dark wavy hair, but ballpoint pen is very effective if used slowly and built up gradually. Note that the area is not simply a mass of a single dark tone; some lines extend beyond the main area to show loose hairs, and light tones are retained to show the glossy highlights.

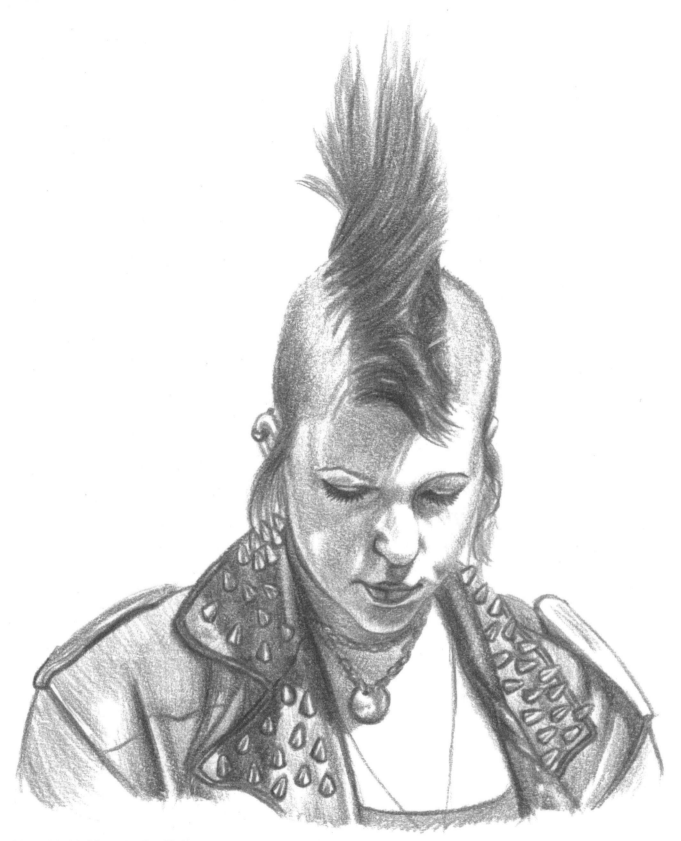

Girl with Mohican in Sunlight

I took this photograph of a young woman with a mohican crest while she was busy using her mobile phone. I just loved the shadows the sun was casting across her face. You have to be confident to create these dark shadows and after using a 2H I used a 2B to darken her face, hair and clothing. Compare and contrast the effects of the materials used for the hair here with those man's hair on the facing page.

ETHNICITY

Whatever the colour of the subject's skin and hair, you need to achieve a full tonal range in your portrait: black skin still retains very light highlights and reflections, and white skin still requires some deep shading in recesses. For this reason, subtlety of tone is important.

It is important to study and follow the contours of the face with your pencil strokes rather than continuously using the pencil to shade only in one direction. This helps to ensure you gradually build up to the correct tone across all of the features.

Hard pencils, such as 2H, are useful for light tones, as you have a great deal of control over the pressure you use. It can therefore be tempting to simply use a soft pencil to achieve deep tones – whether in the wrinkles of skin, or for areas of dark hair – but you can achieve a lot of strength and detail with just lots of soft layers of harder pencils. Work off any sharp bits of a 2H pencil tip on spare paper, turning the pencil so the tip is worn away all around until you have a soft, smooth tip, which can be used with very light pressure to create a lot of depth using multiple layers. This helps to prevent any harsh lines being created which are hard to remove.

To add more depth to very dark skin, it can be useful to use a very soft – 8B, for example – graphite stick to establish the tone, then work over the area with a soft graphite pencil like a 2B. Graphite sticks are softer than normal graphite pencils and blend more easily for a smooth even tone. The harder graphite in a pencil then enables you to get even more depth on top of the tone established with the graphite stick.

A putty eraser, used gently, is very useful to lift off pencil to create light-toned highlights in dark skin.

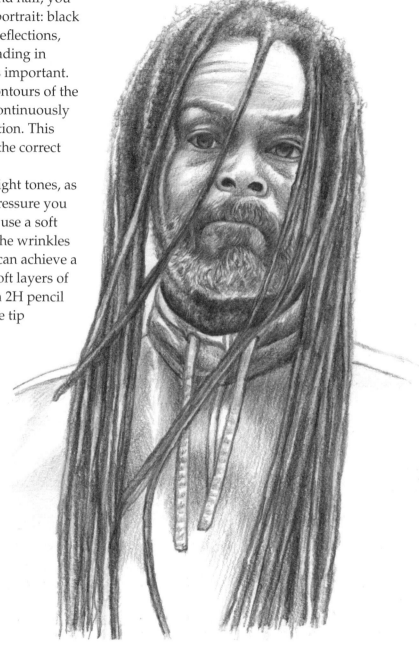

French Stall Holder with Dreadlocks

I thought this man had a really interesting look. With his facial hair and the texture of the dreadlocks against his skin, I just knew he would be great to draw. A 2H pencil was used to build up depth in his face and neck, before a 2B pencil was used for the very deepest tones.

For his beard, I worked a sharp 2B pencil point between all the lighter 2H hairs I had already created for the grey hairs on his chin, to make the lighter hairs stand out. I then made sure that the shadow under his chin on his neck was very dark, creating tonal contrast, so that his chin comes forward out of the picture. The hair on top of his head is quite wiry, so I used a scribble technique to create the texture before darkening his hair and the cast shadows on his face with a 2B to add depth.

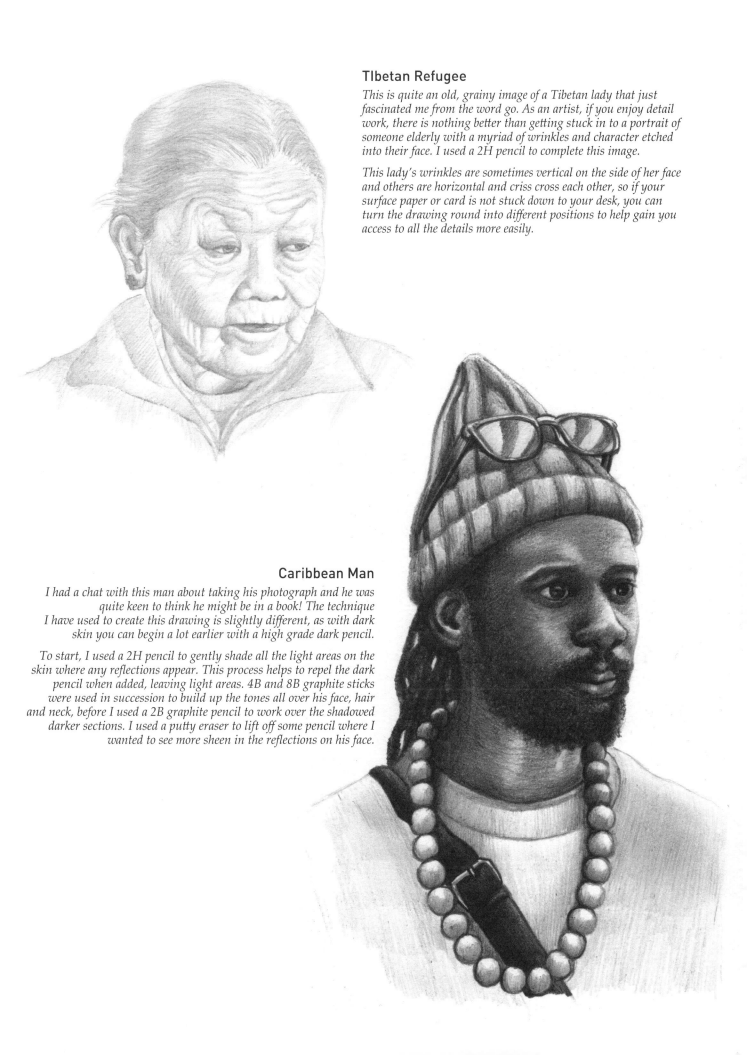

TIbetan Refugee

This is quite an old, grainy image of a Tibetan lady that just fascinated me from the word go. As an artist, if you enjoy detail work, there is nothing better than getting stuck in to a portrait of someone elderly with a myriad of wrinkles and character etched into their face. I used a 2H pencil to complete this image.

This lady's wrinkles are sometimes vertical on the side of her face and others are horizontal and criss cross each other, so if your surface paper or card is not stuck down to your desk, you can turn the drawing round into different positions to help gain you access to all the details more easily.

Caribbean Man

I had a chat with this man about taking his photograph and he was quite keen to think he might be in a book! The technique I have used to create this drawing is slightly different, as with dark skin you can begin a lot earlier with a high grade dark pencil.

To start, I used a 2H pencil to gently shade all the light areas on the skin where any reflections appear. This process helps to repel the dark pencil when added, leaving light areas. 4B and 8B graphite sticks were used in succession to build up the tones all over his face, hair and neck, before I used a 2B graphite pencil to work over the shadowed darker sections. I used a putty eraser to lift off some pencil where I wanted to see more sheen in the reflections on his face.

Tomboy

For this step-by-step project, I have chosen an image that at first glance may seem like an easy option. In fact, there is much more skill required when drawing young people. Smooth skin is harder to draw, and the added interest of dark-toned skin creates its own challenges.

The style of her tunic, along with the strong shapes of the headband and its fastening sticking off at an angle, is uncomplicated but interesting and attractive. The image suggests that she lives a simple life and that there is not much money to spend on clothing. However, her expression is very proud and slightly defiant – almost daring you not to take her seriously.

The girl's stance and her confident expression make a very appealing composition, as does her individual style. It is a perfect example of how focusing on the head and shoulders can make for a more appealing and arresting image than drawing the whole figure.

MATERIALS

Smooth white board, 20.5 x 21cm (8 x 8¼in)
2H, 2B, 4B and 8B graphite pencils
4B graphite stick
Putty eraser
Eraser
Pencil sharpener
Board and masking tape
Rough paper

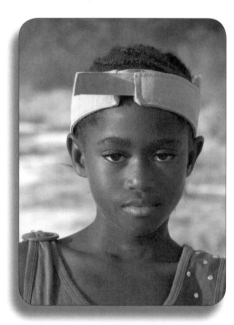

The source photograph used for this project.

1 Use a 2H pencil to draw the outline of the subject as shown. Before you start to shade in her face and neck, use a putty eraser to dab away some of the outline so it is still visible but not too dark.

2 Starting with a smooth-tipped 2H pencil, begin to add reflections on the skin as light areas, using a small circular scribble technique to create some initial texture. If the pencil leaves any hard marks, use your putty eraser to lift them off. Ensure the tip of the pencil is smooth and worn before re-doing the section again. This hard pencil will partially repel the darker pencil added later and help to retain light in the areas of highlight.

3 Change to a 4B graphite stick and use the same circular scribble technique to softly and slowly fill in the darker sections of the face, hair and neck, building up layer by layer. It will look a little grainy as you are working. After the first layer of pencil is in place, you can add gentle pressure to get more depth. Work around the features for the moment – they will be established later.

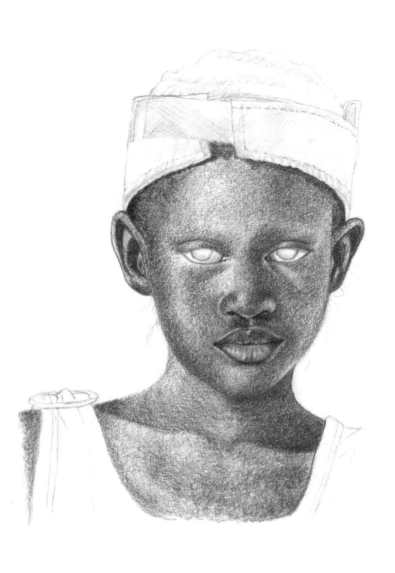

4 Using a 2B pencil, start to place the features softly. Change to the 2H pencil to shade in the lips before swapping back to the 2B to darken them further. The same 2B pencil can now be used over the 4B shaded areas to further darken them. Work in layers and gradually build up the depth. Be careful to retain the highlights, but do gently work the 2B pencil into edges of the light areas to graduate the tone from dark to light.

5 Continue to build on the layers with 2B pencil until you feel it start to skate on the surface. Change to the 4B graphite stick to layer over the darkest areas of the skin once more. With the deep shades established, change back to the 2B pencil to outline the eyes and eyelids gently and draw in the eyebrows. Fill in the pupil and iris in both eyes slowly, taking the lighting direction into consideration. Darken further with the 4B and use 8B to add the dark eyelashes. Darken the neck and chest with the 4B first and then 8B in the darkest sections.

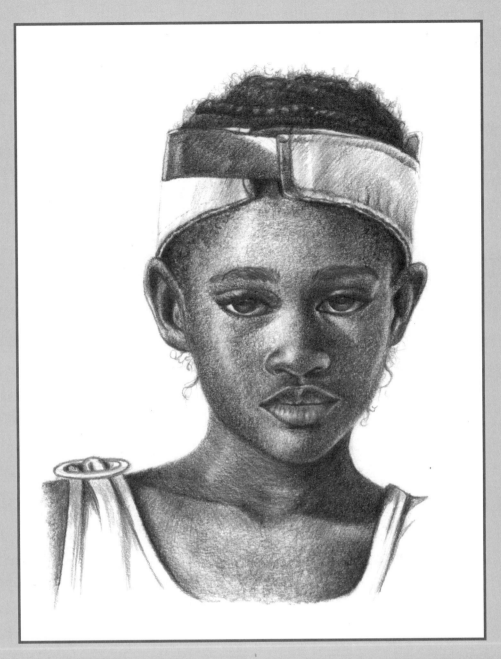

6 To complete the portrait, persevere with building on the depth of the layers using the 4B and 8B all over. Use the 2B pencil to create the hair above her headband and then deepen it using the 4B and 8B pencils. Fill in the headband with 2B first and then 4B. Add some shading to the clothing using the 2B and 4B again and some tendrils of hair around her head with the 2B to complete.

The finished picture
20.5 x 21cm (8 x 8¼in)

Graphite pencil and graphite stick on smooth white board.

HANDS AND FEET

I really enjoy drawing hands though I can appreciate they are not everyone's cup of tea. I could not say exactly why I enjoy drawing them, but it is certainly something to do with the challenge they create and the detail involved. Feet, however, are a different story – if we are being totally honest, they are not my favourite part of the body!

Nevertheless, both hands and feet are important parts of clothed figures, so it is worth practising drawing them. Hands in particular are often visible and can be very expressive elements of a picture.

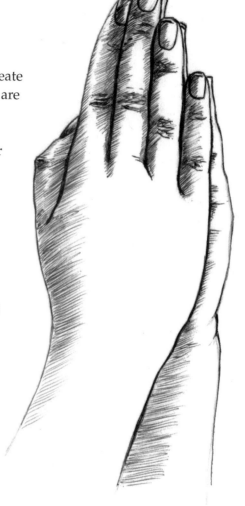

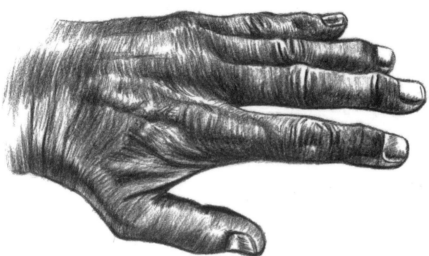

Charcoal pencil really lends itself to the texture and shade of this elderly man's hand. Charcoal is a great medium which allows you to get straight into shading your outline.

It is quite hard to get a neat and tidy finish with ballpoint pen and as I wanted to produce a sketchy look to the finished image of these clasped hands the medium was the perfect option. I naturally have a very controlled style, and using ballpoint pen means I can create a completely different look to my drawings without changing the way I work.

Drawing hands

As I said earlier in the book, try not to get too bogged down in detail until you are happy with the proportion of the hand or hands. Use the measuring technique to gauge the length of the fingers against one another.

There are many types of media you can use to draw hands in particular and I have used a few examples to give you some ideas. The trusty graphite pencil is usually the first tool you think of for drawing and certainly it is a great way to sketch. You can do a rough drawing of the hand you have chosen in a light 2H pencil and then firm up your sketch using a sharp 2B pencil to finish off.

My personal favourite medium is black ballpoint pen because it is very difficult not to end up with a sketchy style drawing. This prevents me from getting too bogged down in producing a perfect, neat outline and also adds a bit of movement.

Graphitint pencils are also a lovely medium as they are easy to sharpen and very soft. You can get quite a lot of depth where required if you build up with the pencils gently.

Perspective plays a big part as well as proportion in producing a well executed sketch. If these skills do not come easily to you, then practice is the only way to improve.

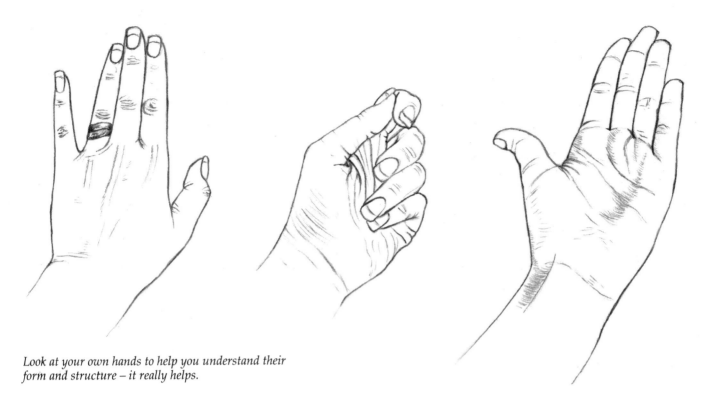

Look at your own hands to help you understand their form and structure – it really helps.

Drawing feet

Toes are like fingers in that they are all different lengths and shapes. Before you draw anything, take time to have a good look at the shape and composition in order to start the way you mean to go on. If you are struggling to see sections properly, do not forget you can always use your own feet as reference. Your toes or the shape of your foot may not be exactly the same as the feet you are drawing but the basic make-up is the same.

If you are drawing the ankles, these can be quite hard, so take your time studying he angles and curves where the foot joins the leg. The shape of the toenails is important too, as they look very different depending on the angle at which you look at them.

I suggest you aim not to include feet positioned straight on in your drawings, as the foreshortening will cause you immense problems. Instead, aim to find a different angle when composing your drawing.

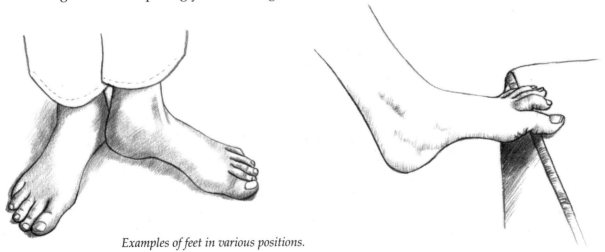

Examples of feet in various positions.

Tying Laces

This project allows you to practise drawing hands and feet, using classic graphite pencils which will help you to achieve a very realistic finish to the drawing. You will see how easy it is to get real depth as you work, even working with just two pencils: a hard 2H and a soft 2B pencil. The softer the pencil, the grainier your image will become. By using only a 2B – rather than a softer 4B or 6B – to enhance the darks, you can create depth while keeping the drawing crisp and clean looking.

MATERIALS

Smooth white board, 21 x 29.7cm (8¼ x 11¾in)
2H and 2B graphite pencils
Putty eraser
Eraser
Pencil sharpener
Board and masking tape
Rough paper

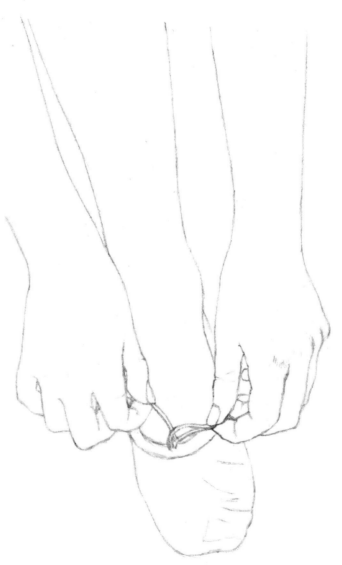

The source photograph used for this project.

1 Use a 2H pencil to draw the initial outline, keeping your touch very light and gentle to avoid scoring the card and creating indentations. Once complete, use a putty eraser to lift most of the pencil away from the outline, leaving just enough so you can still see your drawing. This is to prevent it looking as if you have an outline around your drawing, which will look less professional.

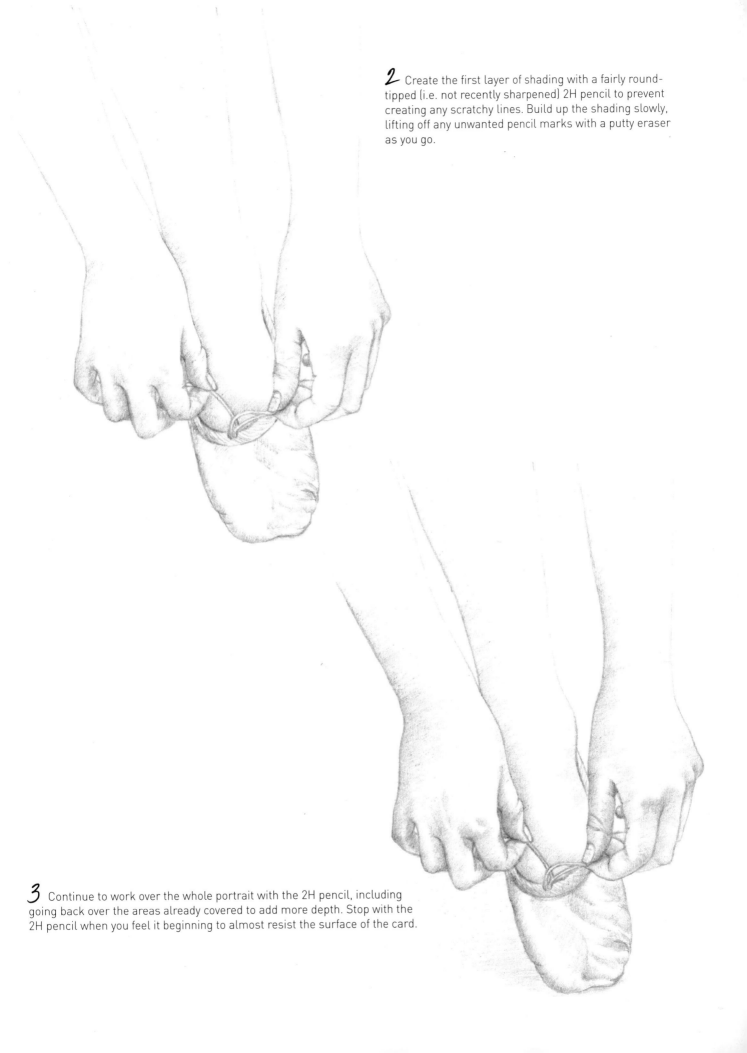

2 Create the first layer of shading with a fairly round-tipped (i.e. not recently sharpened) 2H pencil to prevent creating any scratchy lines. Build up the shading slowly, lifting off any unwanted pencil marks with a putty eraser as you go.

3 Continue to work over the whole portrait with the 2H pencil, including going back over the areas already covered to add more depth. Stop with the 2H pencil when you feel it beginning to almost resist the surface of the card.

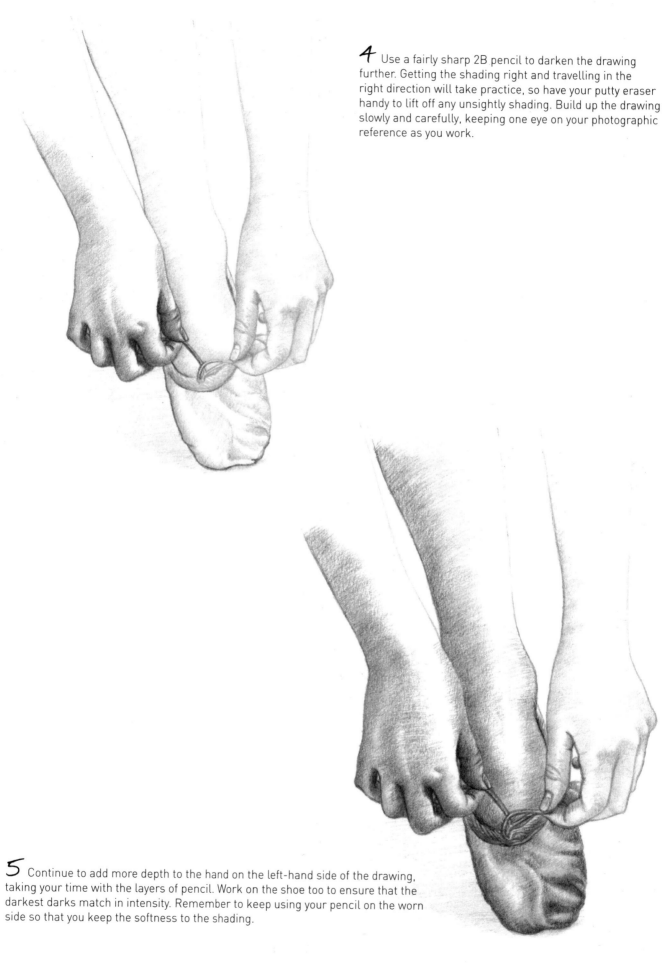

4 Use a fairly sharp 2B pencil to darken the drawing further. Getting the shading right and travelling in the right direction will take practice, so have your putty eraser handy to lift off any unsightly shading. Build up the drawing slowly and carefully, keeping one eye on your photographic reference as you work.

5 Continue to add more depth to the hand on the left-hand side of the drawing, taking your time with the layers of pencil. Work on the shoe too to ensure that the darkest darks match in intensity. Remember to keep using your pencil on the worn side so that you keep the softness to the shading.

6 Build up the hand on the right-hand side of the picture gradually, using soft layers of 2H and 2B where required. Add more 2H to the lightest areas of the arms too and add more depth to the shoe and shadow on the floor. To finish, use the sharp tip of the 2B to really get some very dark blacks into the drawing where you can see them represented in the reference picture.

The finished picture
21 x 29.7cm (8¼ x 11¾in)

Graphite pencil on smooth white board.

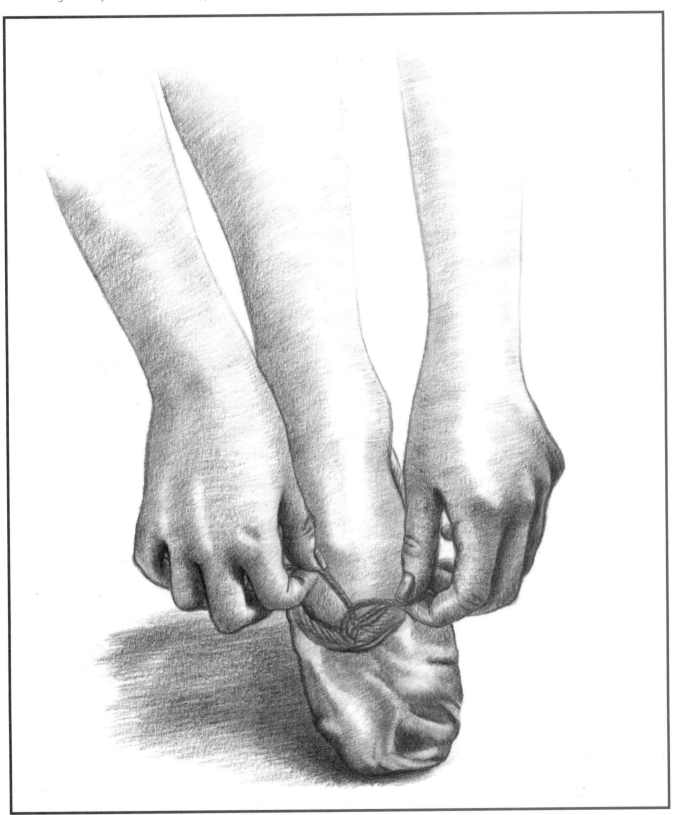

Light and shade

The light that falls on your subject is extremely important. It has a huge bearing on how your figure will look when completed. There are many different ways of lighting your subject, even when you only have the option of using natural light. If you have access to a studio, the lighting is more easily controlled and you have more access to unusual effects, but they can be harsher overall than using natural light. Ultimately, the lighting you use is down to personal choice. This section of the book aims to help you to decide what you want to achieve.

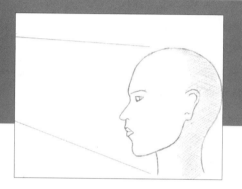

Here, the subject is facing the light source, creating light at the front and shadows behind.

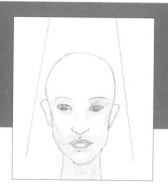

A light source directly above the subject results in deep shadows around the eyes which can give a sinister appearance. Unflattering shadows are cast on the face.

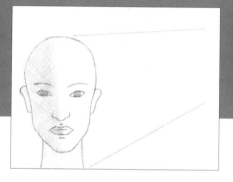

This subject above is being lit from their left side, resulting in shadows mainly on the right side of their face. The opposite is true for the figure below.

LIGHT SOURCE AND DIRECTION

The light source is the point from which the light falling on your subject originates. Look at the shadows cast on the figure and trace where the light is coming from to find the source. The light source affects what you can see of the figure, which can also creates specific effects that might affect the mood. For example, a light source directly above the subject (above centre) creates a very specific and unusual set of effects. Harsh shadows appear on the face. Shadows cast from the brow can add a sinister appeal if this is what you want to achieve.

A light source to the side of the subject, as in the examples to the right, can give a nice balanced effect, with the structure of the face being thrown into relief, and creating a balance between the light and dark tones.

These sketches give only a rough idea of the effects of side lighting on your subject. Studying the light source will make you more aware of natural and unnatural lighting effects, and will begin to develop your own favourites. I recommend looking at lots of photographs to test yourself on how much you can read from the images.

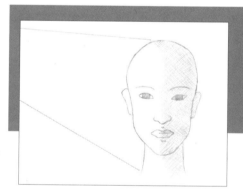

The head sketches on this page outline a few of the most common indoor natural lighting scenarios to illustrate the effects they can cause. Lit from the front (see above left) the figure's face would have no strong shadows to outline the features, resulting in a soft overall appearance. This lighting is very appealing, and most figures – from infants to the elderly– lit this way would look good as long as the light is not too strong.

My preferred lighting

The examples of light direction shown on the opposite page, while useful, do not always give the most pleasing results when drawing figures. Such direct lighting can result in too-bright highlights and hard shadows that obscure detail. While this is useful for certain dramatic effects, it can give the lighting itself too much of a role in the composition.

A simple way to adapt the lighting for the examples on the opposite page would be to turn your subject a little more towards the light (or move the light source, if you are able). This will create lovely shadows on the form and face with some backlighting to accentuate the profile.

My personal favourite lighting is soft side or back light which adds a lot of shadow to the front of the subject but adds interest in the form of slight back and cross lighting. This softer reflected light is slightly dimmer than the direct light, and it helps to add modelling to the figure, softening shadows and adding subtle highlights on the side away from the direct light.

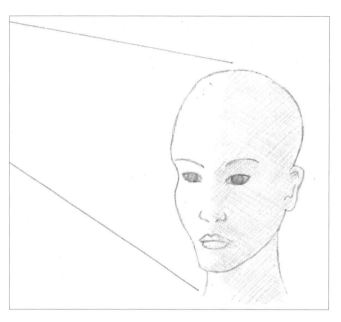

My preferred lighting, shown on a simple sketch of a head to help illustrate the effect.

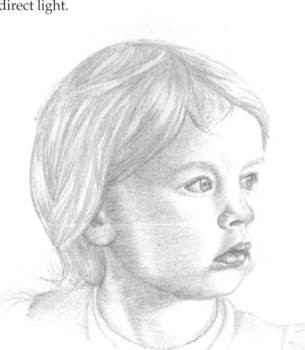

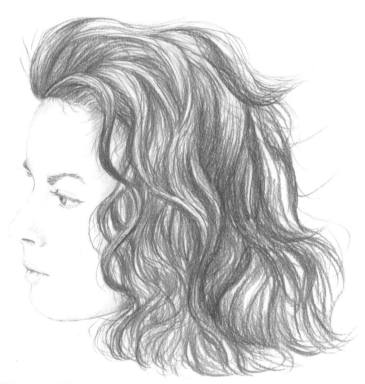

Toddler

Soft lighting suits children well. In this image, worked in 2H pencil on smooth white card, the young girl is being lit by a natural light source slightly above her and on her left-hand side (i.e. to the right of the image). This creates highlights on the side facing the light, while the other side is softly cast in shadow. Her hair contains quite a few highlights, some of which come from reflected light from a mirror behind her.

Woman's Face

Worked in 2H and 2B pencil on smooth white card, this image is an example of harsh lighting. The natural light source – strong sunlight – is shining directly onto the front of her face and bleaching her features slightly. The only contrast on the image is within her hair which is in shadow compared with her face.

LIGHTING YOUR SUBJECT

Lighting for effect

Having spent time looking at your own images and in magazines and books, you will likely already have preferences when it comes to lighting. These ideas should help you decide on what effects you would like to create in order to light your own subjects in your reference photographs.

In general, when you are drawing a figure you should aim to use lighting that is flattering to your subject. Different times of the day will produce different types of lighting situations. The strongest light (depending on the weather) will usually be midday, whereas if you are looking for softer light, early morning or late afternoon is best. Beware of the light being too strong, resulting in the subject flinching, or squinting.

Using soft lighting will minimise wrinkles, and so would typically be used for an older subject. However, you may wish to deliberately draw attention to the age of the subject in order to add interest and character to the piece, in which case you could purposefully choose a harsher lighting option in order to exaggerate the age of their skin.

Controlling the light

Of course, choosing the light for your drawings relies on you being able to control the light. As I mentioned earlier, one of my personal favourites is lighting the subject from the back, but what if you are outside and can not control the lighting? The first option is to go indoors and use artificial lighting. This is more easily controllable, but can be a lot harsher than natural light. Unless you have access to a studio with the equipment available to combat that issue, I recommend you use natural light where possible.

You can use natural light indoors, by sitting your subject near a window. When you are shooting photographs of your subject indoors, think carefully about where you are going to position them. Sitting someone near a window to take advantage of maximum light is ideal but you need to also consider how you want the light to fall on your subject. If you want a fully-lit face, seat them facing the window. If you want a half-lit profile, seat them side-on to the light. With the window behind them, you will get dramatic backlighting.

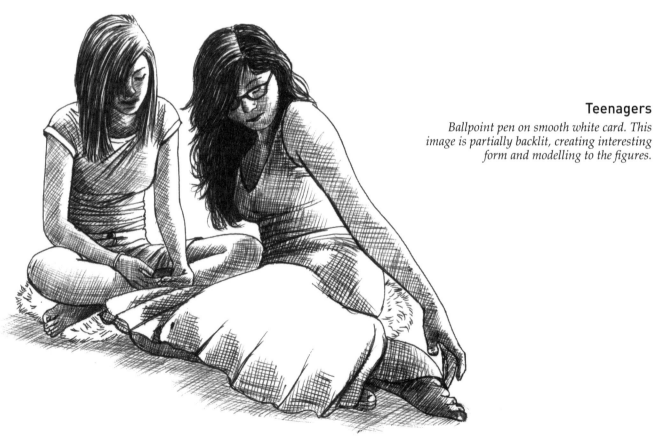

Teenagers
Ballpoint pen on smooth white card. This image is partially backlit, creating interesting form and modelling to the figures.

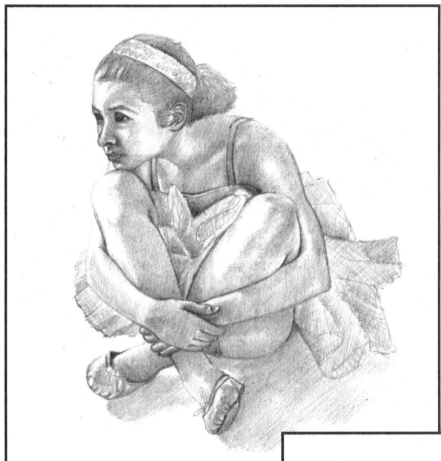

Holly

The light source here is coming from a window on Holly's right hand side. Her body is turned slightly away from the viewer, resulting in shadows that fall across most of her body.

The higher surfaces catching the light are her face, knees, right arm and left foot. However, because of the angle of her body and the light source being higher than her (she was sat on the floor), there is also light hitting areas of the left-hand side which adds more interest. The time of day was mid-afternoon so the light is soft. This results in soft shadows, which is very attractive.

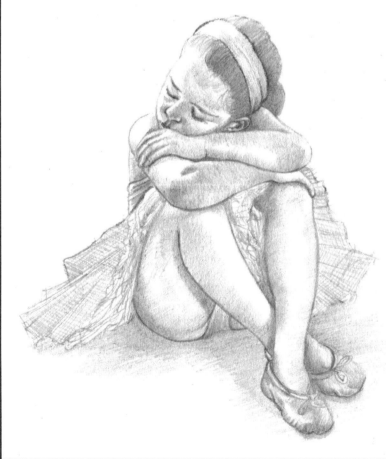

Taya

This sketch is lit in much the same way as with Holly (see above) but Taya's back is to the light source, so she is facing more towards the viewer. The light again results in very soft shadows on the figure with most of the direct light falling on her face, right side and right arm, but with reflected light on her left hand, left arm and left foot too.

Both images were created using a hard 2H pencil in several layers gradually building up the depth with a worn-down tip. I then sharpened the pencil at the end to sharpen some lines and areas within the figures.

CREATING DRAMA WITH LIGHT

Strong sunlight and dark shadows are fantastic to replicate in your drawing as they are so striking. However, the technique requires confidence because if you do not create the dark shadows the bright highlights will not truly stand out and the overall effect will be lost.

Practice and a lot of observation are the only way to get this right. Balance is the key and you have to be careful as you can also get too dark in places if you are not careful. Step back every so often and try to view your drawing objectively to check the balance of the darks and lights. Better still, take a photograph and view it on a computer or laptop to see how it is coming along – I find this helps immensely!

Tonal contrast and drama

The images shown here contain very strong lighting, deep shadows, or both, so carbon pencils were the perfect choice to use. These pencils are very soft and extremely dark so the effects are very striking and the drama is easy to create more quickly than with graphite pencils.

All three pictures were drawn on smooth white card. I sketched the drawings using a 2H graphite pencil first, then knocked back the image slightly with a putty eraser before starting to add tone, as pencil tends to repel carbon pencil.

The lovely thing about carbon pencils are that you can still achieve quite a high level of detail or you can simply use them to create a quick and very complete-looking sketch. They are perfect for showcasing dramatic lighting.

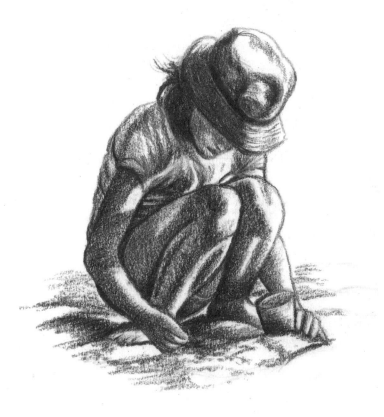

Girl on Beach

This sketch was worked as described above, with a 2H graphite pencil, then a B graphite pencil, and finally a 2B carbon pencil to add depth. The highlights within the image are left almost white to accentuate the contrast, which gives the effect of showing just how strong the bright sunlight is in the scene. With less tonal contrast, the drawing would not be nearly as dramatic.

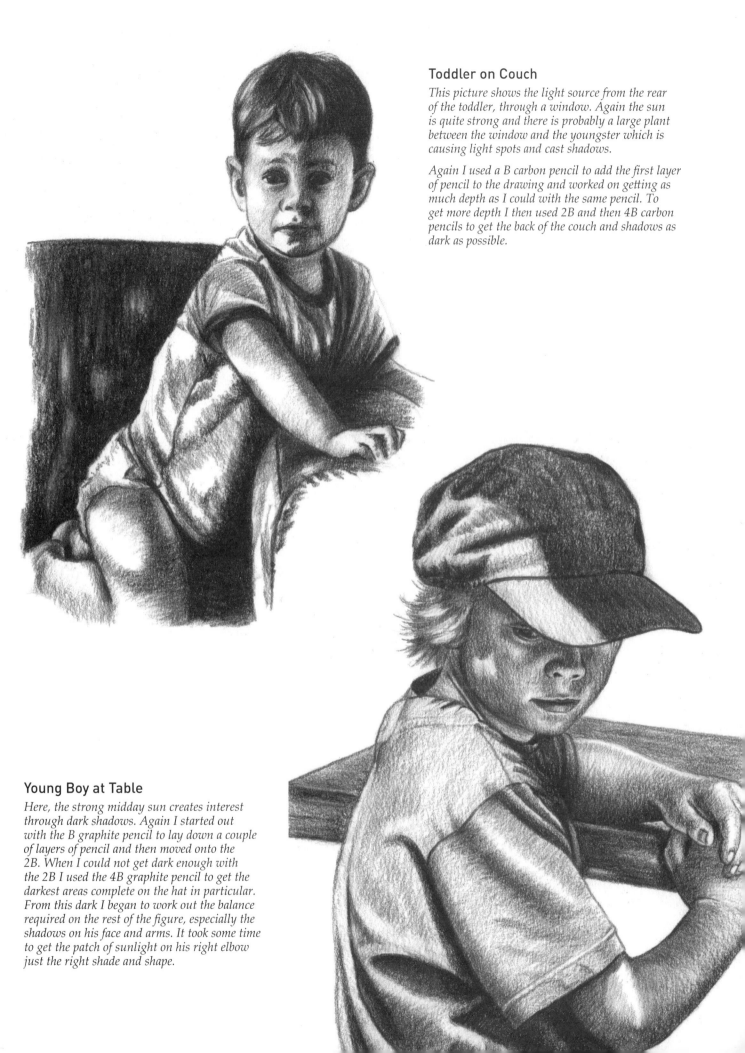

Toddler on Couch

This picture shows the light source from the rear of the toddler, through a window. Again the sun is quite strong and there is probably a large plant between the window and the youngster which is causing light spots and cast shadows.

Again I used a B carbon pencil to add the first layer of pencil to the drawing and worked on getting as much depth as I could with the same pencil. To get more depth I then used 2B and then 4B carbon pencils to get the back of the couch and shadows as dark as possible.

Young Boy at Table

Here, the strong midday sun creates interest through dark shadows. Again I started out with the B graphite pencil to lay down a couple of layers of pencil and then moved onto the 2B. When I could not get dark enough with the 2B I used the 4B graphite pencil to get the darkest areas complete on the hat in particular. From this dark I began to work out the balance required on the rest of the figure, especially the shadows on his face and arms. It took some time to get the patch of sunlight on his right elbow just the right shade and shape.

CAST SHADOWS

I love looking at photographs of people with very strong shadows cast onto them – I find them mesmerising! Just thinking about trying to replicate these effects really inspires me. Shadows are fascinating and not easy to draw. You really need to study lots of different types and have a go at sketching them to try and get it right. Some shadows have very clear, crisp edges whereas others fade out with blurred edges.

Cast shadows are created by strong light sources, such as bright sunlight or powerful artificial lamps. The light casts the shapes of intervening objects – palm trees, straw hats, Venetian blinds and so forth – onto the figures underneath or beside them. While you are unlikely to focus solely on the shadows themselves (though as the examples on these pages show, it is a fun challenge!), cast shadows offer a great way to add interest and depth to your drawings of clothed figures.

The shadows cast by objects can be almost exact replicas of the article themselves. For instance, trees can cast some stunning shadows of leaf formations on the ground around a subject when the sun is high above. These are even more interesting to watch if the wind is blowing, making them sway and cross over one another.

You might also like to include the shadows cast by the figures themselves, as these can offer some interesting challenges. They can be extremely shortened or elongated, distorting the shape of the owner, or more similar in length, depending on the time of day and how high or low the sun is in the sky.

When you are relying solely on natural light, you will obviously need strong sunlight to create the shadows for you. Different times of the day will give you varying lengths of shadows and the proximity of your subject to an inert object will also determine how crisp the edges of the shadow will be.

Cast Shadow on a Tree

This drawing, of my daughter's shadow cast onto a tree, was made during the late afternoon, with the sun firmly behind her and still quite strong. This accounts for the fairly sharp image, which clearly shows the shape of her clothing and even her outstretched fingers.

However, if she had stepped closer to the tree, the result could have been even more striking. Note how the shadow stands out while still ensuring that the texture and pattern of the tree show through. Shadows are never just solid black, they can vary in depth but always reveal the surface of the object or subject on to which they are cast.

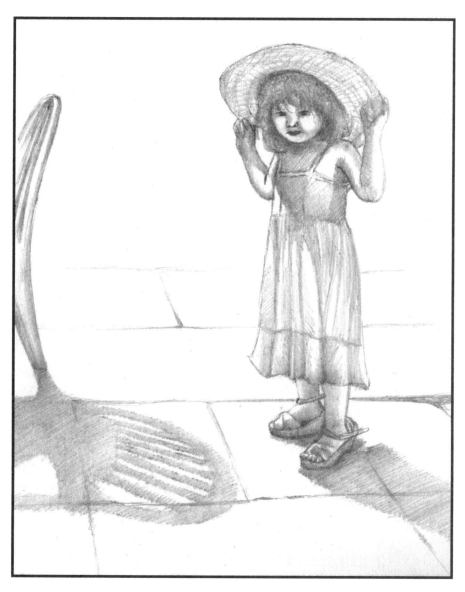

Big Sister's Shoes

The sun is high in the sky for this sketch of a young girl dressing up in her sister's hat and shoes. I have accentuated the shadows on the girl's arms, making them quite harsh so that the white areas clearly depict strong sunlight.

The most interesting shadow being cast is that of the chair. Although it is mostly out of shot, because the shadow is so crisp, you can see exactly what it is representing. This helps to give a sense of scale to the figure.

Shadows can be difficult to reproduce. You must take care not to make the shadow too dark or the surface it is being cast onto will not show through – the paving slabs in this example show how the gaps between the stones are still visible under the shadow.

When adding shadows, ensure that your pencil marks are created by shading consistently in the same direction. This helps avoid adding a distracting sense of texture to the light.

Family Portrait

This illustrates just how much information you can glean from looking solely at shadows, without seeing what has cast them. These shadows have been created during mid afternoon – the longer the shadows the later in the day they were produced.

You can see clearly that the children are situated either end of the group, with mum and dad in the middle and that the family are all holding hands.

The fact that the shadows are well defined suggests that the sun in still fairly high in the sky, although slightly to the left-hand side of the picture and that the distance of projection is relatively short.

Little Ballerina

This step-by-step focuses on the lighting. The young girl is sitting on the floor facing a window and is being lit by natural light only. The composition of the subject facing the window has ensured that the shadows created on her body are dense and the shadow on the floor is cast directly underneath her.

Before you start to draw any subject, even if you have taken the original reference photograph yourself (as I have with this one), always spend some time studying it first so you are sure you will be able to truly translate what is happening to the viewer. For instance, in the reference photograph, there is a section of the girl's left wrist and forearm showing just beyond the hand clasping her right wrist. At first glance it may be difficult to see what it is, or you may not even have noticed it at all. I know from experience that parts like this add little important information to this composition and that the finished picture is likely to be better without the potential confusion.

In this project I include the odd part of the wrist in the initial outline to demonstrate this and show you how to adapt to remove an unwanted part later, in order to achieve a more harmonious finished picture.

MATERIALS

Smooth white board, 29.7cm x 42cm (11¾ x 16½in)
2H, 2B and 3B graphite pencils
Putty eraser
Eraser
Pencil sharpener
Board and masking tape
Rough paper

The source photograph used for this project.

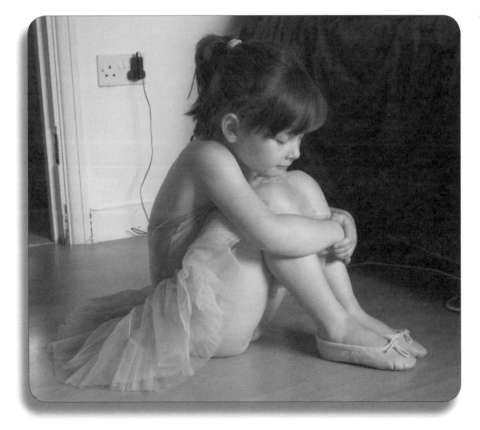

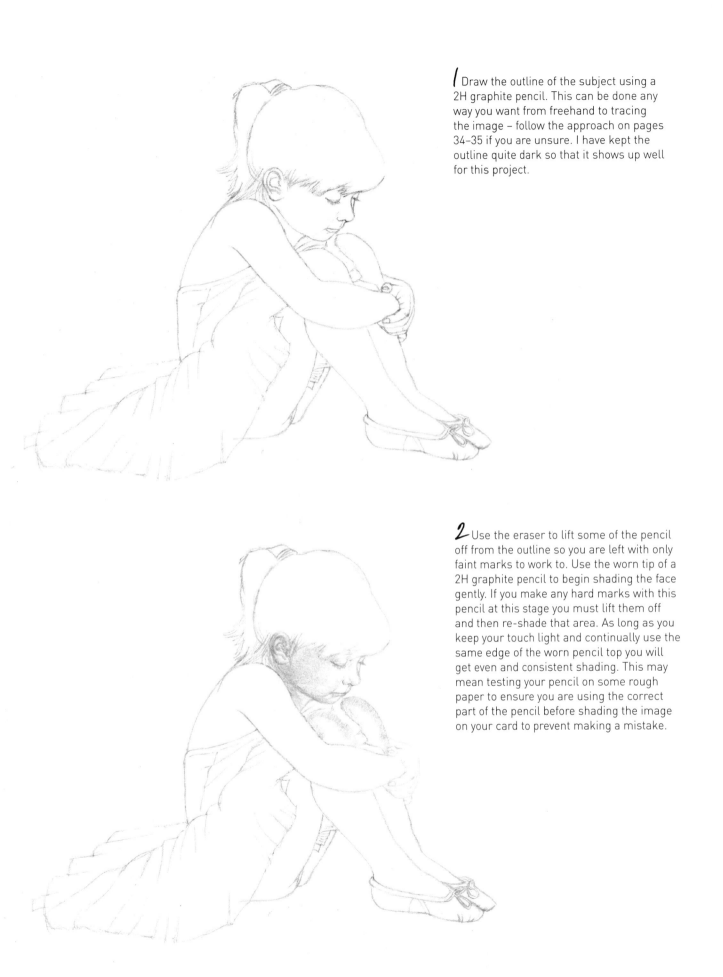

1 Draw the outline of the subject using a 2H graphite pencil. This can be done any way you want from freehand to tracing the image – follow the approach on pages 34–35 if you are unsure. I have kept the outline quite dark so that it shows up well for this project.

2 Use the eraser to lift some of the pencil off from the outline so you are left with only faint marks to work to. Use the worn tip of a 2H graphite pencil to begin shading the face gently. If you make any hard marks with this pencil at this stage you must lift them off and then re-shade that area. As long as you keep your touch light and continually use the same edge of the worn pencil top you will get even and consistent shading. This may mean testing your pencil on some rough paper to ensure you are using the correct part of the pencil before shading the image on your card to prevent making a mistake.

3 Continue to use the 2H pencil to work down the body in the same way as before in the previous step. At this point, the extra bit of arm visible behind the hand (see inset) starts to become confusing as the tone is developed.

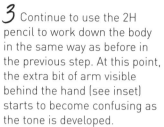

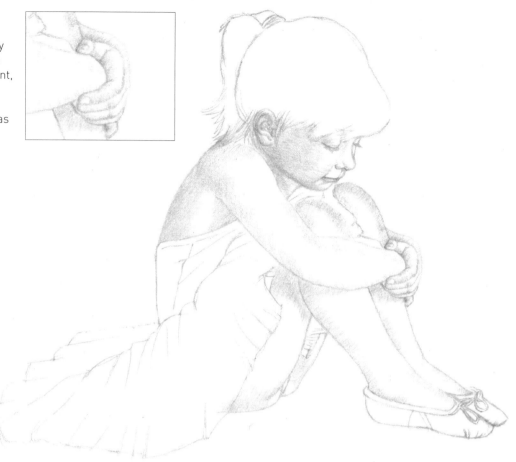

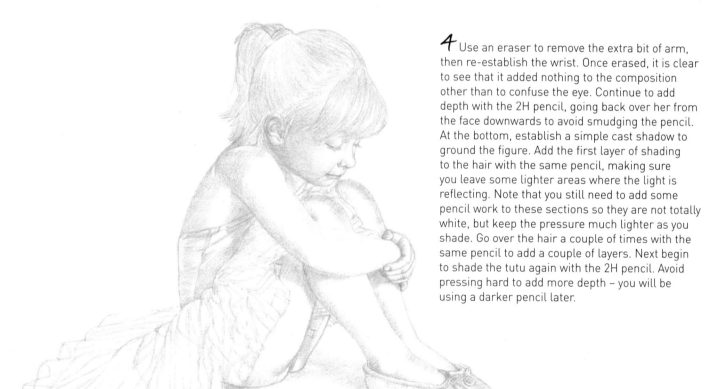

4 Use an eraser to remove the extra bit of arm, then re-establish the wrist. Once erased, it is clear to see that it added nothing to the composition other than to confuse the eye. Continue to add depth with the 2H pencil, going back over her from the face downwards to avoid smudging the pencil. At the bottom, establish a simple cast shadow to ground the figure. Add the first layer of shading to the hair with the same pencil, making sure you leave some lighter areas where the light is reflecting. Note that you still need to add some pencil work to these sections so they are not totally white, but keep the pressure much lighter as you shade. Go over the hair a couple of times with the same pencil to add a couple of layers. Next begin to shade the tutu again with the 2H pencil. Avoid pressing hard to add more depth – you will be using a darker pencil later.

5 Sharpen a 2B pencil and use it to develop the darker tones. Concentrate on getting the hair as dark as required, dragging the pencil through the lighter reflections so these sections do not stand out but rather merge gently into the dark areas. The hair is the darkest part of the subject and once it is complete you can use the hair to gauge the other darks and shadows on the body. Sharpen the pencil again and use it very softly to build up the shadows around the ear, neck and side of her face. Keeping the pencil sharp, darken the features on her face.

6 Continue to work down the body with the sharp 2B pencil, adding more depth with further layers. There is one more pencil to come to help add still more depth, so do not press too hard with the 2B at this stage.

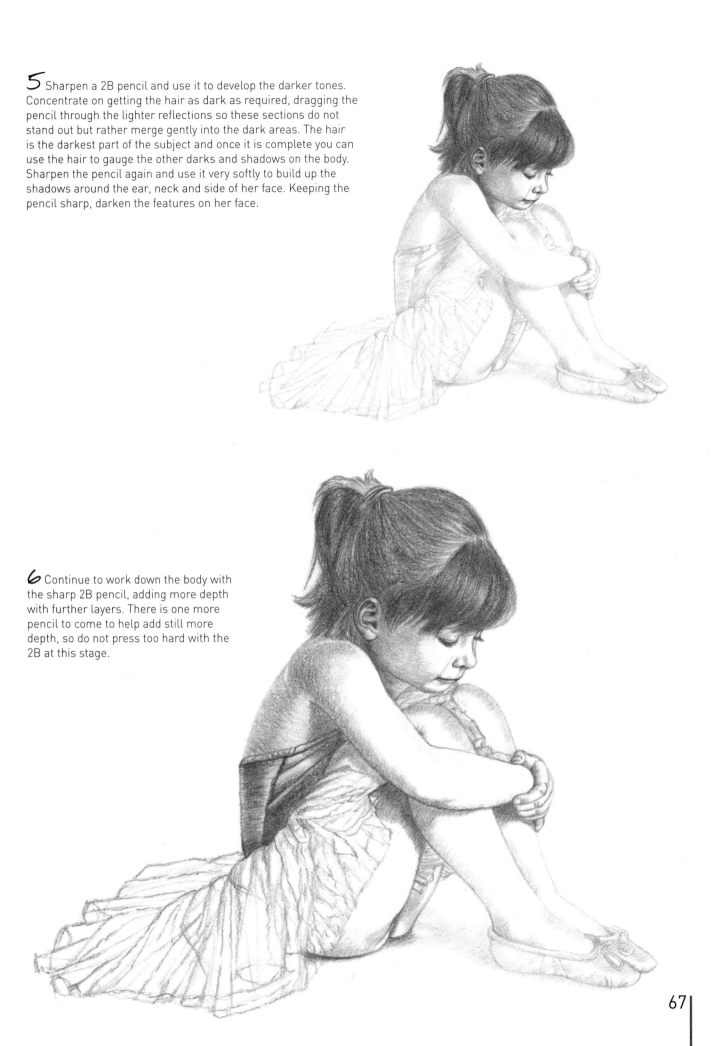

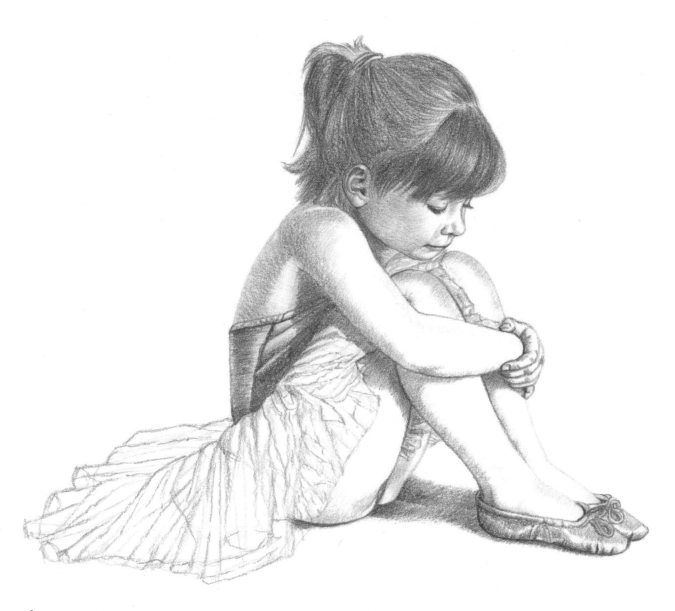

7 Finish working on the body and clothing, including the legs, feet and ballet slippers with the 2B pencil, keeping it sharp throughout. Go back over any shadows that are looking a little wishy-washy and darken the shadow being cast on the floor beneath her.

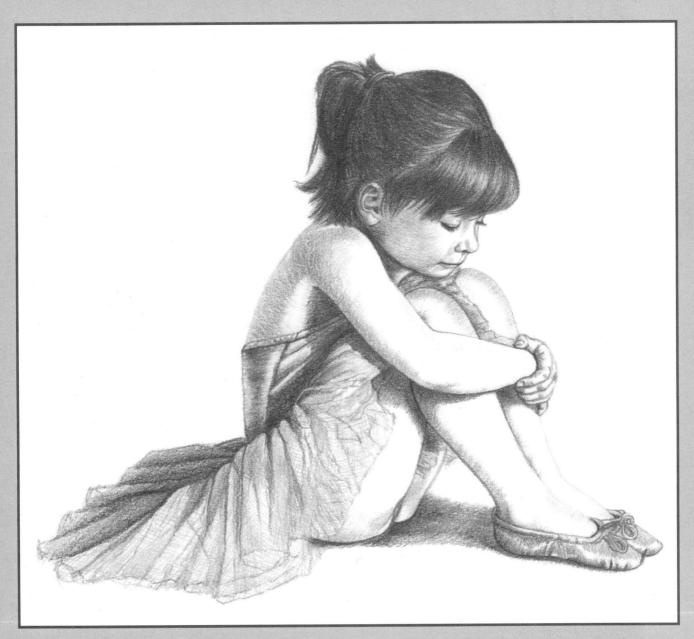

8 Sharpen the 3B pencil and use it to add the deepest tones over the figure and clothing. Add more depth to the tutu bodice and skirt, creating shadow over the area of skirt behind her on the floor. Keep the skirt to the front light in comparison. If you feel you have been a little heavy-handed with some light areas, simply roll up your putty eraser, press it to the surface of the card and lift off any excess pencil. Do this as much as required to bring back any highlights. To finish, darken the shadow cast by her body onto the floor.

The finished picture
21 x 15cm (8¼ x 6in)

Graphite pencil on smooth white board.

Clothing and textures

Drawing the clothed figure is much more difficult than drawing the typical nude life drawing because of the form being covered by fabric.

THE BODY AND CLOTHING

To appreciate how to draw the figure in clothes, you need to know what is going on underneath! If you are not familiar with the make-up of the body, you may find drawing people harder. Practise to make yourself aware of the body beneath the clothing. Along with close observation, the more effort you put into this, the better.

Clothing generally forms creases and folds where the body bends – at joints and around hollows and swells like stomachs and chests. Being able to portray these folds is key to producing convincing clothing in your drawings. Common folds that we take for granted are created by bending knees and elbows, for example. The pictures on the following pages focus on some individual body parts to illustrate what I mean.

Clothing also behaves differently depending on the fabric, cut and shape of the clothing. Denim jeans invariably touch the body (or at least skim it in places) which highlights the body's form. Contrast this with a loose, flared skirt for instance, which masks much of the form.

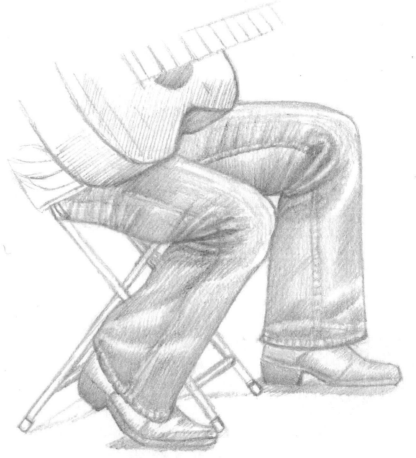

Guitar Man

This man is sitting down while playing. You can see the tension being created in the denim on the bottom and the back of the thighs, which creates thick creases. These creases are even deeper and more pronounced on the bent knees, especially on the leg nearest to us, as it is bent at a greater angle than the other leg. You can even see the outline of his knee on this nearest leg as the material is so taut and stretched. The folds drop away more gently as the material widens and becomes more generous from the shin downwards.

Bent Elbow in Soft Fabric

When you start to study creases and folds on arms, you can get a good idea of what is going on underneath, even with the arm encased in quite chunky material. There is a lot of excess material on the sleeve of this dressing gown, but you can still distinguish the bent elbow by the partial spirals created by the compressed fabric. The folds are much more condensed where the arm is bent in towards the face and gathers into softer folds as it is less restricted moving up to the shoulder.

T-shirt Detail

This detail, taken from the picture of a boy in a T-shirt on page 61, shows how posture can affect the clothing and folds too. You can tell he is relaxed by his rounded back position. The fabric is not strained because the body is relaxed and so the folds being created are gentle and flowing.

FITTING AND SHAPE

When you draw material, remember that you are sketching something soft – be careful not to represent the folds with sharp edges. As with the body itself, careful attention to the shape and texture of clothing will pay dividends. Do not be tempted to put creases or detail where there is no texture.

Tight-fitting clothing will follow the body shape, and loose baggy clothing may simply hang from projecting body parts like shoulders. Similarly, clothing does not remain pristine. It may gradually fray, fade or become worn, wrinkled or baggy with time, so do take care to portray this accurately.

Loose and Layered Clothing

This man, sitting on a bench, is wearing a few layers of clothing due to the time of year and they are all fairly loose on him. Because of his relaxed stance, there are barely any creases or folds being created, especially on his arms. In fact you can see that there is quite a bit of distance between the folds, indicating that the material is barely being compressed as his arms are quite floppy. The full image can be seen on page 77.

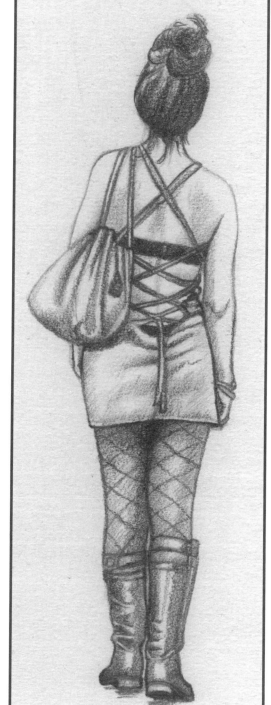

Dressed to Impress

In contrast to the loose layers of the detail above, this quirky young woman is dressed in tight-fitting clothing which means there are very few folds where the fabric is touching her body. The only giveaway to the shape of her bottom is where the material of the skirt is puckered, suggesting a curve underneath. Her boots, however, show ingrained folds at the points where they regularly flex – the ankles – and slightly higher up where they have loosened with wear on her calves.

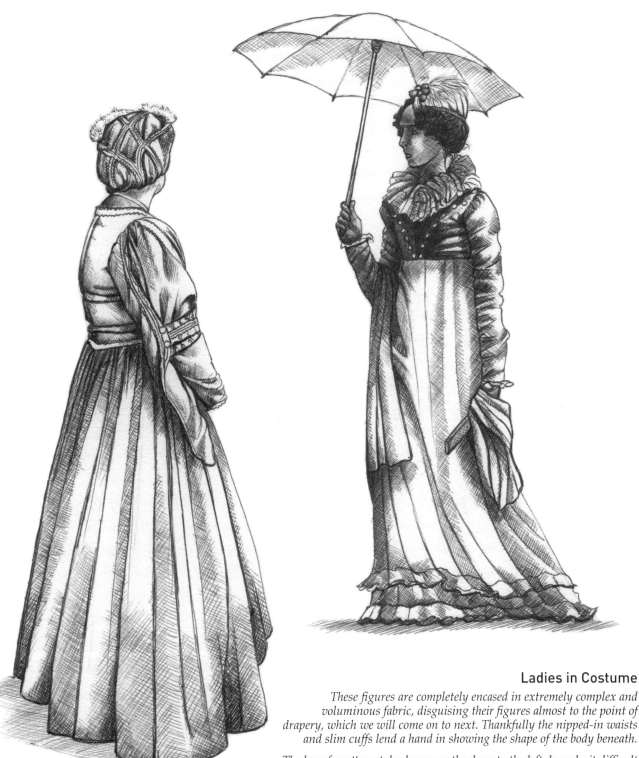

Ladies in Costume

These figures are completely encased in extremely complex and voluminous fabric, disguising their figures almost to the point of drapery, which we will come on to next. Thankfully the nipped-in waists and slim cuffs lend a hand in showing the shape of the body beneath.

The leg-of-mutton style sleeves on the dress to the left do make it difficult to identify the shape of the arm beneath as there are no folds to give us clues. The tight creases on her back suggest that the dress is slightly ill-fitting in this area and gives an accurate description of her posture under the fabric. With the skirt being so full and wide, there is no way of knowing exactly how she is standing, but luckily we do not need to draw her legs as long as we accurately draw the folds and pleats of the dress.

The other lady's posture shows she is walking proudly. If you look carefully, you can see that the material infers movement through the way it is falling at an angle at the bottom of the dress. The skirt is skimming her figure and the tight-fitting bodice shows the shape of her torso. The fabric on her arms is heavy and slightly restrictive and this is causing spiral folds to cascade down the arm hanging down in particular, enhancing the tapering shape underneath.

DRAPERY

Due to the fabric being draped over a human form, rather than fitted and shaped to it, drapery is slightly more challenging than other clothing to replicate because there is less visual information. The body shape will usually be quite obscured and you will have to rely on your powers of observation and basic knowledge of anatomy to fill in the blanks and help you to create your drawing. As a result, understanding the folds and the structure of the body is even more important.

Lighting will have a big impact on the folds. The more light there is, the more the folds will stand out and the darker the hollows between them will appear. The best way to comprehend how drapery twists and turns and how particular fabrics behave is to practise drawing the material itself in isolation.

Learning how fabric drapes and holds shapes in isolation will prove very helpful when it comes to drawing it accurately on the organic curves and shapes of the human body.

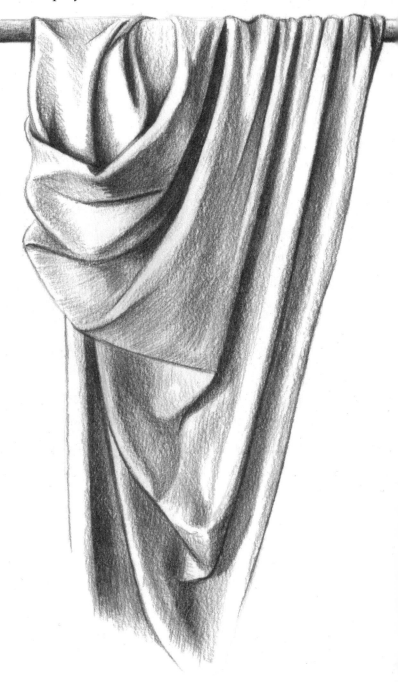

Curtain Swag

This image is of a swag of curtain material which has been looped and wrapped around a curtain pole. This material has nothing to cling to apart from the top bar where the folds are tightest. The remainder of the folds are all falling softly towards the floor with the pull of gravity, where the material is most abundant and weighty.

I lightly drew out the basic image using a 2H pencil and then began to fill in the dark areas between the folds with a soft 6B graphite stick. I constantly referred to my photographic reference to ensure that I understood the relationship of the folds and the effect the light source was having on the material.

As I worked I kept looking at the depth of the darks in the photograph and gradually darkened mine to match. Once I was confident I had the darkest dark on my paper, I used that to compare the rest of the fabric for depth overall. The darker the shadows, the further my folds stood out. Towards the end I used my putty eraser to pick off some pencil on the top of the folds where they were lightest.

Man with Umbrella

With some practice of pure fabric folds under your belt, you will be ready to begin drapery on the human figure. This man's clothing shares similarities to the curtain swag on the opposite page. The main difference is the pattern which, although an added complication, helps to show how the material is affected by the way it has been draped.

Because the fabric is not covering the whole of his torso, you can still see the shape of his shoulders and his arms. This makes drawing the top half of his body slightly easier. Because the material of the tunic has been nipped in at the waist with a belt, you also have an idea where his hips and legs begin. The man's weight is mainly on his right hip (his right leg is straight and left leg is bent) which has caused the folds in the skirt of the tunic to shift at an angle to the right. Again, as the tunic ends just before the knee, you have enough information to complete his bare legs and feet. Look for visual cues like these when drawing to help get an accurate and realistic finish.

Remember also to bear proportion in mind as you work, and use your eye and the measuring technique (see page 27) to help complete the image of a balanced body shape.

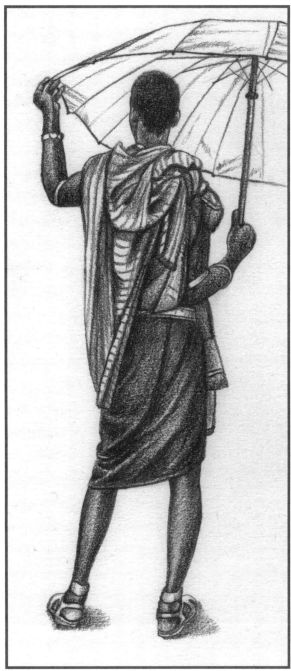

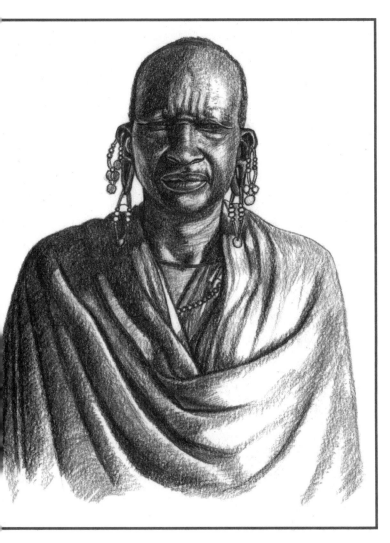

Tribesman with Jewellery

This drawing is an example of a figure draped completely in material. The only clue to his anatomy is how closely the fabric hugs his shoulders and then falls in deep folds around his chest and torso. There is a suggestion that the fabric is quite thick and voluminous in the way it hangs in deep loops at the front.

Getting the proportion of the shoulders correct will ensure the success of this drawing. Using the measuring technique to ensure that you have the correct width of his shoulders in comparison to the size of his head will help you with the outline. You can gain some information regarding his general body shape by how the material is draped and fitted on the figure.

Capturing character

Character is a difficult concept to pin down in drawing, and relies mostly on close observation of a person's posture to suggest their attitude. This is the stage where we are putting most of what we have practised so far together into complete drawings. Elements from drawing faces, composition, lighting and clothing will all be used in this section.

APPEAL AND SPONTANEITY

When trying to capture character, it is easy to get bogged down with detail and miss the initial appeal that drew you to the figure. Spontaneity is key. Posed or stiff source material can hide the sitter's character. Part of capturing the character of a person is getting your reference while they are relaxed, so be discreet and patient when finding your source material. The following images show you how you can illustrate character just as well with a simple line sketch as with a more developed drawing.

Kerbside Snack

This boy sitting on the kerb having a snack with his mum and brother was a perfect subject – too good to resist! I have developed a great fondness for the softness of carbon pencils and the instant darks you can achieve with it. I drew a sketch with a 2H pencil so that I had a basic outline to work from, then used a putty eraser to lift away some of the pencil, leaving enough that I could still see a faint outline, as I find graphite tends to repel carbon pencil a little. I started building up the tone in layers using a B carbon pencil. When I sensed the B could not achieve the darks required for the deep shades in the jeans and hat in particular, I changed to a 2B carbon pencil to complete the drawing.

Park Life

Here is an example of capturing character with a simple line drawing. There is no shading within the figures themselves but you can still see expression and posture, which gives an impression of what is going on. People on benches are a brilliant source of reference, especially if you can inconspicuously take photographs from a distance while they are unaware and relaxed!

Man and Metal

In contrast to the line drawing opposite (Park Life), this example includes some shading to add more depth to the subject, though I have kept tight control over the overall style. Once you have your quick line sketch down on paper in light pencil, you can use a ballpoint pen to develop the drawing more confidently later.

Adding the tattoos as a solid colour has helped to give a better idea of the character of this man, and providing more detail in the clothing also adds interest. I have made him appear a little more menacing than he actually was but this helps to demonstrate that you can exaggerate character to good effect.

Guitar Player

Continuing on the bench theme, here is another great character seemingly unaware of having his picture taken. Drawn using carbon pencils in a rougher style than that of the drawing above, there is more of a feel of speed about this picture – it is much more sketchy, even though I have incorporated shading and dark shadows. There is not a lot of fine detail in the face, but you still get an overall impression of the subject's character from the composition and clothing.

Catching Up

I think you will understand why I found this image particularly striking and felt compelled to draw it. I really admired the way that the photographer had managed to take a picture of his subject looking directly at the camera but in such an unaffected way.

Most of you will have experienced asking someone if you can take their picture. What generally happens is that all spontaneity is lost, as is the connection you had with your subject while they were unaware you were studying them. People become self-conscious and ill at ease with themselves. This has not happened with this particular subject – he is still confidently reading his newspaper and seems completely unperturbed by the imposition of being photographed. His clothing and relaxed manner, along with the challenge of the detail within the newspaper, really appealed to me and I hope you enjoy drawing him too.

MATERIALS

Smooth white board, 21cm x 30cm (8¼ x 11¾in)
2H graphite pencil
B and 2B carbon pencils
Putty eraser
Eraser
Pencil sharpener
Board and masking tape
Rough paper

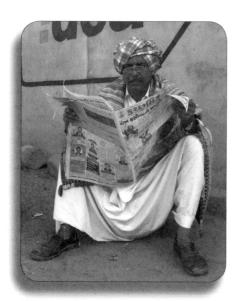

The source photograph used for this project.

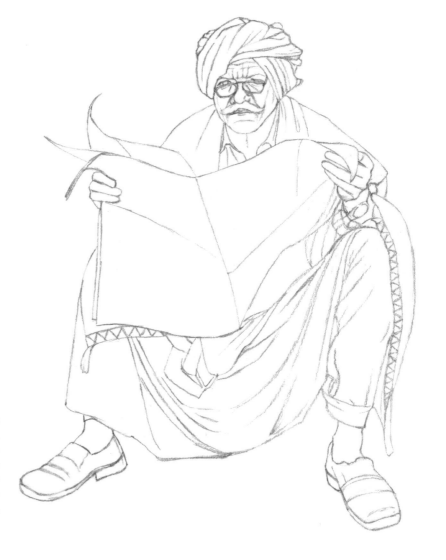

1 Use a fairly sharp 2H pencil to draw the outline of the subject. Keep the pencil marks light or they will be difficult to erase. Graphite pencil tends to repel the carbon pencil we will be using later, so once you have a complete outline, use the putty eraser to lift off some of the pencil so that you are left with just a faint outline.

2 Now sharpen the B carbon pencil and use it to draw a light outline over your original graphite pencil outline. This helps to hold the pencil within boundaries as you are shading. Starting with the turban, add the pattern to the fabric (it does not have to be exact, just enough to add interest) and then do the same with his cloak. Next, sharpen the B carbon pencil again and begin to add the detail on the newspaper. Take into account the folds and the effect the creases are having on the print and images. Finally add some light shading where the paper is creased and folded over in places.

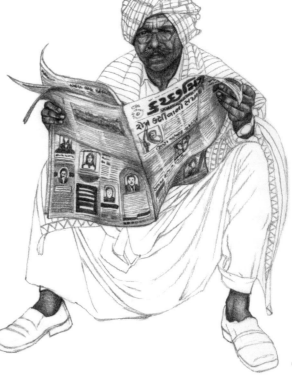

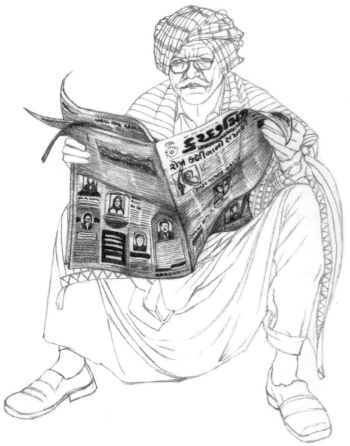

3 Ensure the B carbon pencil is sharp, then begin working on his face. Start by adding the creases to his forehead and outlining his features and glasses to preserve your original sketch. Next, start to shade the face gently with a light layer of carbon pencil – this medium is difficult to lift off if it has been applied heavily, so the lighter you apply it the easier it is to correct errors. It is almost impossible to completely remove the carbon with a eraser, but you can take off the majority and re-apply more correctly over the top. Continue to build on the depth of the shading to darken the face slowly. Sharpen the pencil and outline the moustache, then use the carbon pencil to create the texture, leaving small white gaps to represent the grey hairs. Gently create the mouth and then move on to complete the shading on the neck. Go back to the face to add some stubble to the chin area where you can see it on the reference picture.

4 Sharpen the B carbon pencil, then continue working down the figure, using the same technique as for the face. Lightly outline the hands and feet first to ensure the proportions are correct before shading, then begin to shade the hands in layer by layer to darken them gradually. When the hands are complete, move onto shading the ankles.

5 The next part to complete is the clothing. Starting with a sharp B carbon pencil begin to mark out the pattern of the turban and shade appropriately. You don't need to copy the exact pattern of the fabric, just add enough to show the twists and turns in the material. Add a little shading to make the turban appear more three-dimensional where the shadows have formed. Continue down to create the cloak draped over his shoulders and knees. Again create the pattern the way you want it to appear. Shade the folds of his white tunic lightly where you can see the shadows on the reference picture. Be careful how much you shade it as you do not want it to appear grey!

6 Sharpen the pencil again and begin to add a layer of shading to his left shoe. When you can feel that the pencil is shading as dark as it is able (without increasing the pressure on the card) sharpen the 2B carbon pencil to give the shoes some extra depth. Leave a light section in the centre (lightly shaded – not white) to represent the shin. Lift off some carbon if you feel this area isn't standing out enough once the shoes are complete.

7 Go back over the drawing with a sharp 2B carbon pencil, darkening where required. Use this pencil to add more depth to the shadows on and around the face and also the features including the mouth and the shadow created by the edges of the turban where it meets the face.

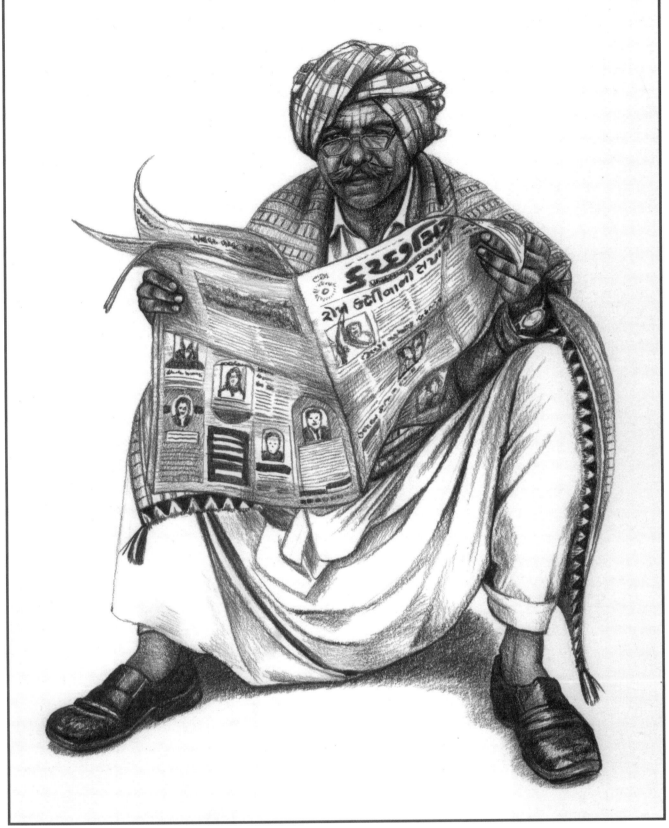

8 Add some crisp edges to the folds in the tunic and darken the pattern within the fabrics on the turban and cloak where necessary. Continue down towards the floor and use the B carbon pencil first to create the first couple of layers of shadow under the seated figure. Shade with the pencil at the same angle throughout or the shadow will not appear flat. Do not forget to place some shadows under the feet. To finish, go back over the shadow again, shading in the same direction as before and concentrating the darkest area directly underneath the figure.

The finished picture
21 x 21cm (8¼ x 8¼in)

Graphite and carbon pencils on smooth white board.

Pose and movement

The way a person stands or moves makes a great difference to creating an engaging drawing. Action of any sort can be a difficult to portray in a drawing. If, like me, your technique does not naturally lend itself to sketchy, fast lines, you have to think of other ways to help get the message across to show movement.

DYNAMIC POSES

Movement through medium

Trying to capture movement and portraying that in your drawing can be quite difficult, so choose a medium that you feel will help get the message across. I often choose to illustrate movement with ballpoint pen as it is it more difficult to achieve a refined drawing with this medium. As a result, it automatically suggests a little movement, as shown in the pictures on these pages.

Draw your subject with a 2H pencil first to give yourself a little more confidence, then use the ballpoint pen in continuous lines to complete your sketch. To avoid having to stop, make sure you can see where your next line is headed before you put pen to paper, so that you can complete it in one go if possible. If you stop while drawing a line, continuing without the ballpoint pen producing a splodge of ink or a slightly off-kilter join will be very difficult, so keep it moving. However, in some cases this stopping and starting may add more interest and movement to your sketch – so just have a go!

Movement through pose

Pose and balance can also help to suggest movement. The pictures on the right show the figures slightly off-balance, with their centres of gravity suggesting they are moving. This suggestion can be reinforced through the clothing, by having it follow the direction of movement.

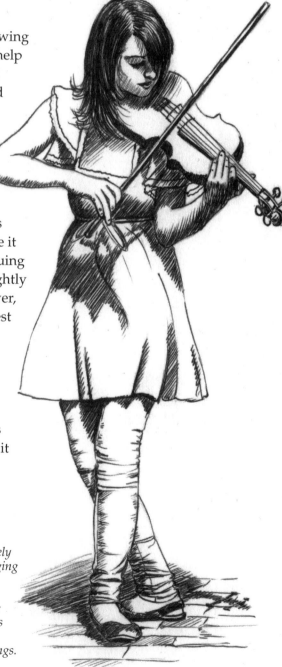

The Violinist

This is a picture of a young violinist that I took in London. She was completely caught up in her music and was totally unaware of the crowds of people surging around her. I loved the way the sun caught her moving form and the intent expression on her face as she played. It is very rare for someone to stand still while playing a musical instrument, especially the violin. So although I have captured a still moment of her playing, the viewer would realise that this was exactly what they were seeing. Again the ballpoint pen lends itself perfectly even though my shading technique is less erratic than in the previous drawings.

The Tango Dancers

Common dynamic poses are those of dancers. This couple dancing the tango is an example of sudden movement. There are rare moments of stillness within the dance, this being one, but the dynamic tension suggested by the leg positioning implies to the viewer that they will continue the dance at any moment.

I have kept the ballpoint pen shading rather erratic and it has a slightly unfinished and hurried look to it – all intentional I assure you! These techniques all help add the illusion of movement to an otherwise static drawing.

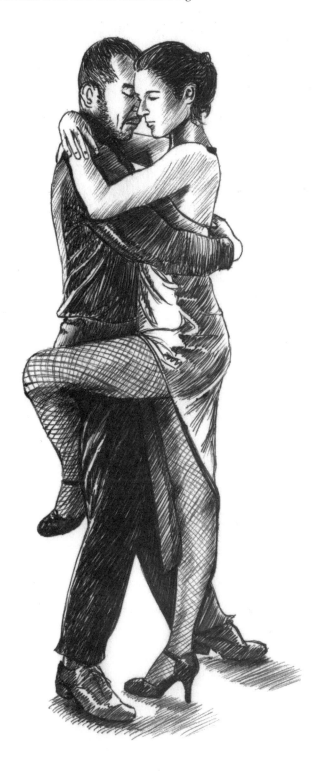

The Street Dancer

This woman was dancing in the street at a festival and the pose suggests she is in the middle of her routine. She is holding up the hem of her dress as she dances and her left foot is in the air showing that she is in mid-action.

The clothing also appears to be swaying due to the movements she is making and the ballpoint pen accentuates and reinforces this impression as it is such a fine and feathery-tipped medium.

WORKING POSES

You can take some good photographs of people working any time while you are out and about. You can also try sketching directly from life – studying the effects movement has on the body and even just observing can be fun and educational. There are so many examples of the working figure that the opportunities are enormous.

However, if your subject is going to be aware that you are sketching or photographing them, it is a good idea – and only polite – to ask their permission first.

Young Woman Sewing

This image is one I took of a young woman sewing while travelling on the train. She set up her impromptu little sewing workshop in seconds, as soon as she boarded, and was soon lost in concentration. She was not distracted in the least when I asked to take a photograph of her working. The pose itself was very appealing to draw because she was totally immersed in her sewing. Her expression shows her concentration and dedication to her task.

When I had drawn a pencil sketch, I loved how simple the image looked and decided to keep it that way with a line drawing in ballpoint pen. The hair worked especially well and I felt the ballpoint pen added an almost cartoon element to the sketch which I would not normally look to achieve. I think it worked well.

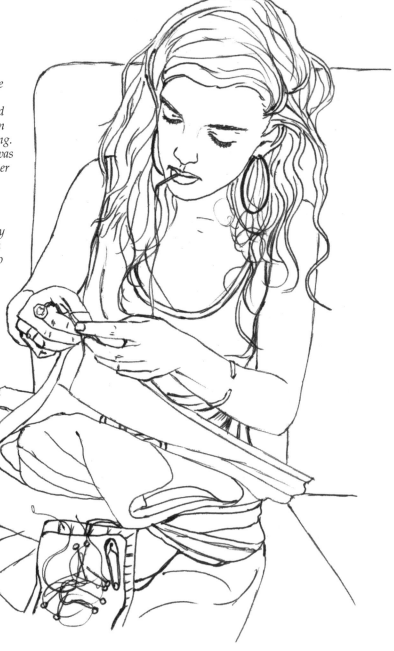

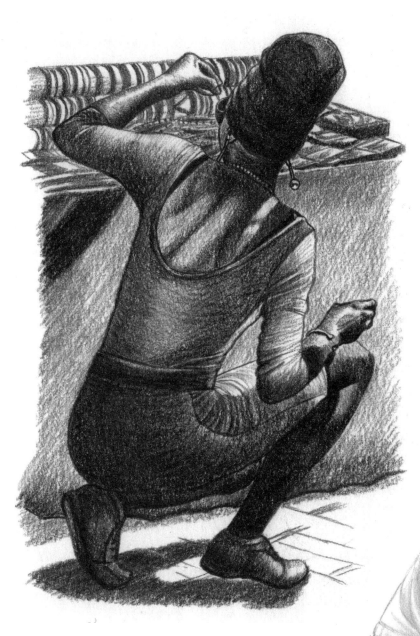

Caribbean Stall Holder

This sketch was produced from another of my photographs. This lady was the life and soul of the market and would not stand still! She was such an interesting character that I was determined to take a photograph of her. By the end of the day I had a few to choose from. This one was taken while she was serving a customer. Just before this I had watched her wind her long dreadlocks up into this turban – no mean feat, but she made it look so easy.

As a particular pose to draw I admired her athletic physique and the way that she was effortlessly crouching for quite a length of time, whilst adjusting the products on her stall table. Her leanness was apparent in the fit of her clothes and the lack of creasing and bulging within the fabric of her dress. She was a very striking figure to draw.

I used a B carbon pencil to draw out the main outline after sketching lightly in graphite pencil and lifting the excess off with a putty eraser (remember graphite repels carbon pencil). I shaded with the B and then darkened and added more depth where necessary with 2B and 4B carbon pencils.

Biltmore Estate Ironmonger at Work

This particular image of an ironmonger working appealed to me because of the concentration and strength he was illustrating while completing the task at hand. You can see how tightly his hands are wrapped around the hammer and iron he is shaping while hot.

I decided to complete this drawing simply, using just a 2H pencil. As the pencil tip was quite worn, it allowed me to create a darker drawing than if the pencil had been sharp and scratchy.

FIGURES AT REST

The opposite end of the scale to dynamic, working figures has to be figures at rest. Whether someone is asleep or simply taking a break, if you look around you when you are out and about you will find constant sources of reference. Benches or outside seating areas are great places to observe people relaxing, as are cafés and restaurants.

Almost all children are great to watch when they are resting as they are generally absorbed in something else and totally unaware of the world around them. In contrast, adults can be very unpredictable and different from one another. For instance, some people sitting alone in a café come across as self-conscious and uncomfortable, whereas others are clearly very relaxed in their own company. People watching can be great fun!

Hard Labour Break

This is an image of a worker in Dubai resting halfway through the day after heavy labouring. The high contrast meant the best medium to create this image was carbon pencils. I sketched the complete outline in 2H graphite pencil then lifted off the excess pencil so that the outline was only just visible. This reduces the chance of the graphite repelling the carbon pencil. I then began to fill in the subject and the hand cart with a B carbon pencil, eventually moving on to the darker 2B and 4B as more depth was required in the shading.

Lazy Afternoon

Technical pens are less likely than ballpoint pens to produce an unattractive heavy ink spot or splodge on your drawing if you pause with your pen tip still pressed to paper, making them ideal for a clean look. I wanted to make this image look almost cartoon-like and ink is perfect for that. I used a 0.35mm (¹⁄₆₄in) nib, which produces a smooth line of medium thickness. A faint pencil sketch from which to work allows you to be quite confident with your pen strokes. The overall effect is very neat and tidy and by keeping shading to a minimum, the drawing stayed very simple looking — exactly what I wanted to achieve.

Young Girl Sleeping

This lovely picture of a young girl sleeping really appealed to me because of the soft focus and almost dreamlike quality of the original photograph. I wanted to keep these qualities in my drawing and so I used only a 2H pencil with a worn tip to draw my outline and gently build the drawing using three layers of pencil. Using the pencil worn rather than sharp prevents you from creating stark detail which could spoil the overall effect.

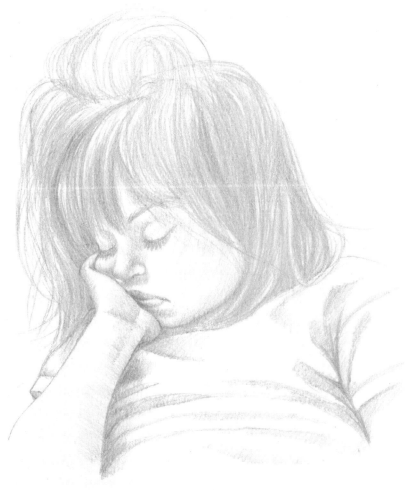

87

Interaction

Observing people interacting, whether in pairs or groups, can be absolutely fascinating. Whenever people are sitting together, you can see the diverse mixture that makes up our world very clearly.

GROUPS OF FIGURES

When I look closely at groups seated together, I always gain immense fun in trying to establish the relationships between them. Are they friends? Have they literally just struck up a conversation there and then as strangers? You can judge by a persons' body language just how comfortable they are at being seated in close proximity to a complete stranger. Some people are much more at home in this situation than others. Close observation will help you spot groups that will make for good compositions.

On the Bench

This first image illustrates exactly what I mean by body language and the eclectic mix of people you can find on one bench. I think you can quite easily work out that there are two couples on the bench and one man on his own who is the odd one out. His body language suggests that he is keen not to be associated with the others on the bench. The lady on his right has likewise turned more towards her partner to subtly shut him out.

This comic twist is important to this group image, and the fine lines created by technical ink pen portrayed this well, as it enabled me to work in very fine detail to capture the subtlety. I drew a sketch of the basic outline with a 2H pencil and then began to complete the image with a 0.5mm (¹⁄₃₂in) tip technical ink pen.

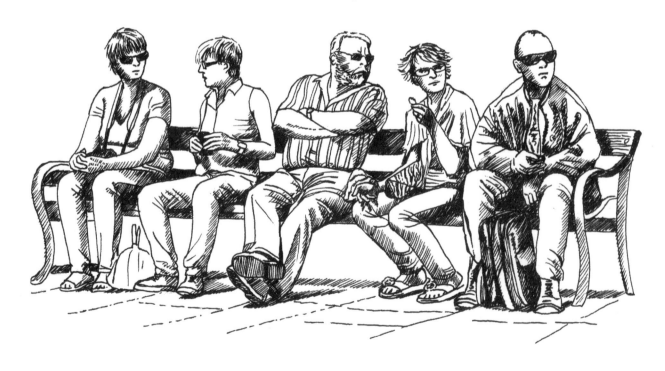

It's All Up For Discussion

I love how all of the people at the table are such characters and are so obviously caught up in a truly animated conversation. The folds and curves of the fabric are full of directional lines and contrasting tones, and it is this that gives the drawing a sense of action and brings across the characters of the men at the table in the finished piece.

In order to get the contrasting tones that are needed, I drew a light sketch first and then drew the outlines with a fine-tipped liner pen. I then used brush pens to fill in the clothing where appropriate, choosing a mid- and dark grey. I used thick-tipped black pen for the coats of the men at the front and the darks within their turbans.

Ladies Resting in the Sun

These three ladies relaxing on a stone bench in the sun are clearly comfortable in close proximity – likely a group of good friends. I loved the composition in the photograph and the way they all seemed so content to share the seat. Keep an eye out for natural compositions like this.

To capture the moment, I sketched the outline in 2H pencil then used a fine-tipped liner pen to draw the subjects. Instead of the traditional line shading or cross hatching to depict shadows, I used small spots to create shading – this is called stippling. When darker shading is required, place the dots closer together. When less depth is necessary, space the dots further away from each other.

Four Heroes

Who could resist working from this group image? The bench helps to create a perfect composition. I am assuming that these men were all known to one another by their relaxed positions and the close-knit way they are seated on the bench. There seems to be quite a diverse age range throughout the group which lends the image even more character. Their clothing is a great source of reference with lots of textures and creases to work on and their facial expressions are a real challenge.

I decided that the perfect medium to create the casual air for which I was aiming would be black ballpoint pen. It would also add a looseness of style to the sketch, which is very much in keeping with the character of the image and the postures of the men.

By this stage, you should be comfortable with all the drawing techniques and compositional cues explained in this book, which gives you free choice over how you create this drawing. You might choose to draw it tightly, as shown in the project here, or you might choose to adapt the project to use a technique with a quick and less controlled look. It is entirely up to you!

MATERIALS

Smooth white board, 42cm x 30cm (16½ x 11¾in)
2H graphite pencil
Black ballpoint pen
Correction fluid pen
Putty eraser
Eraser
Pencil sharpener
Board and masking tape
Scrap paper

The source photograph used for this project.

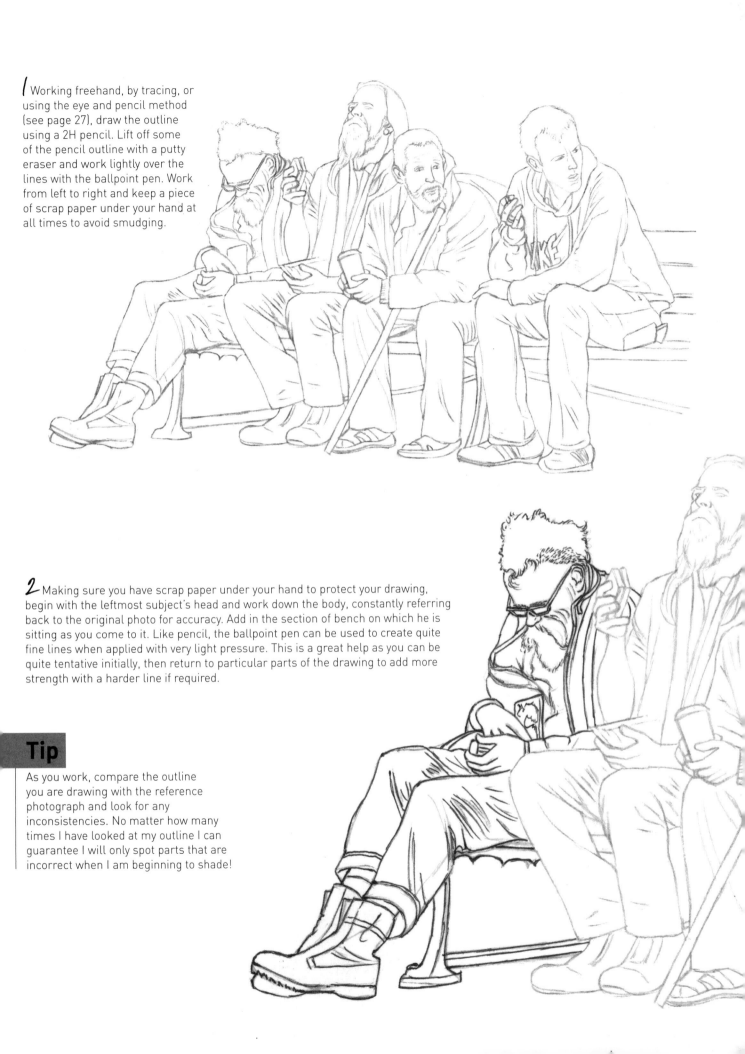

1 Working freehand, by tracing, or using the eye and pencil method (see page 27), draw the outline using a 2H pencil. Lift off some of the pencil outline with a putty eraser and work lightly over the lines with the ballpoint pen. Work from left to right and keep a piece of scrap paper under your hand at all times to avoid smudging.

2 Making sure you have scrap paper under your hand to protect your drawing, begin with the leftmost subject's head and work down the body, constantly referring back to the original photo for accuracy. Add in the section of bench on which he is sitting as you come to it. Like pencil, the ballpoint pen can be used to create quite fine lines when applied with very light pressure. This is a great help as you can be quite tentative initially, then return to particular parts of the drawing to add more strength with a harder line if required.

Tip

As you work, compare the outline you are drawing with the reference photograph and look for any inconsistencies. No matter how many times I have looked at my outline I can guarantee I will only spot parts that are incorrect when I am beginning to shade!

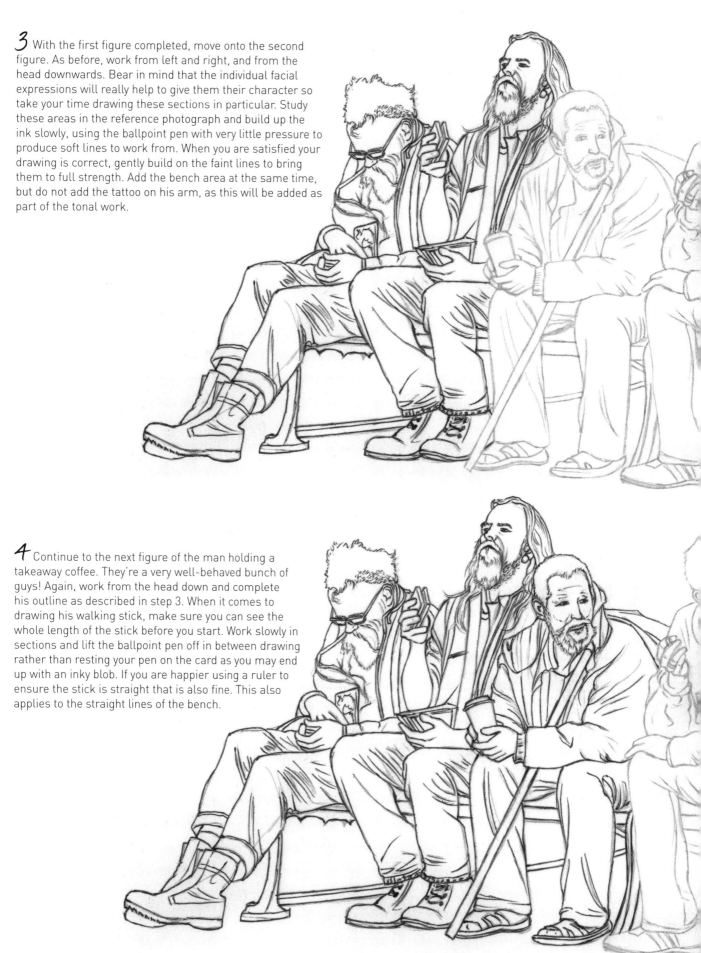

3 With the first figure completed, move onto the second figure. As before, work from left and right, and from the head downwards. Bear in mind that the individual facial expressions will really help to give them their character so take your time drawing these sections in particular. Study these areas in the reference photograph and build up the ink slowly, using the ballpoint pen with very little pressure to produce soft lines to work from. When you are satisfied your drawing is correct, gently build on the faint lines to bring them to full strength. Add the bench area at the same time, but do not add the tattoo on his arm, as this will be added as part of the tonal work.

4 Continue to the next figure of the man holding a takeaway coffee. They're a very well-behaved bunch of guys! Again, work from the head down and complete his outline as described in step 3. When it comes to drawing his walking stick, make sure you can see the whole length of the stick before you start. Work slowly in sections and lift the ballpoint pen off in between drawing rather than resting your pen on the card as you may end up with an inky blob. If you are happier using a ruler to ensure the stick is straight that is also fine. This also applies to the straight lines of the bench.

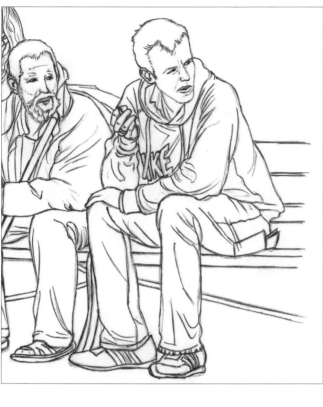

5 Complete the rightmost figure and the remainder of the bench in the same way as the others. By now you should be more confident with the ballpoint pen and your strokes, so this last subject should be the easiest to draw.

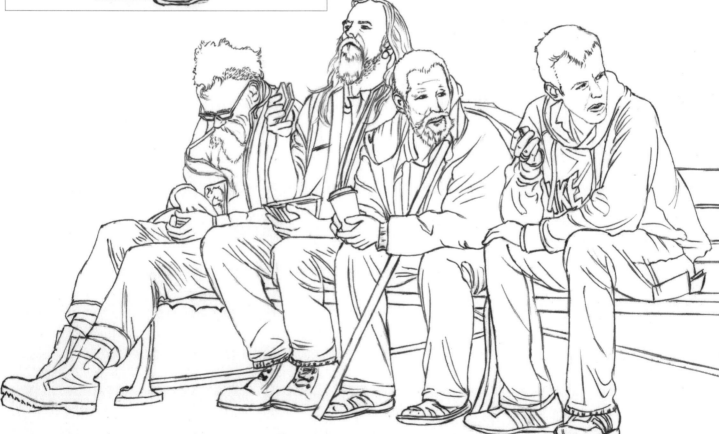

6 Before you begin to shade in the drawing you need to remove the original pencil outline. There will be a big improvement in the fineness of the lines when this is done. Do ensure that your outline is completely dry before you attempt this – perhaps after a cup of tea and a break! Use a standard eraser to work over the drawing, being especially careful when you come across any heavy ballpoint pen marks or blobs. When you have done this you will be able to appreciate fully what removing the pencil does to your outline.

7 The main drawing is now complete and ready to add shading and shadows to take it from just a line drawing to something more real. Remember to keep the rough paper under your working hand at all times, especially now. Decide on a shading direction and try to keep this consistent throughout for the same body parts or clothing. Start with the leftmost figure, working down from his head to his boots, shading the bench at the same time. Try to work out ways of using the ballpoint pen to keep the details but also to add depth where required. Pay particular attention to the hair, adding more texture with the ballpoint pen. Build up the jacket to an almost solid black and use less pressure for the t-shirt underneath to produce a shaded garment but with a less solid finish than the jacket.

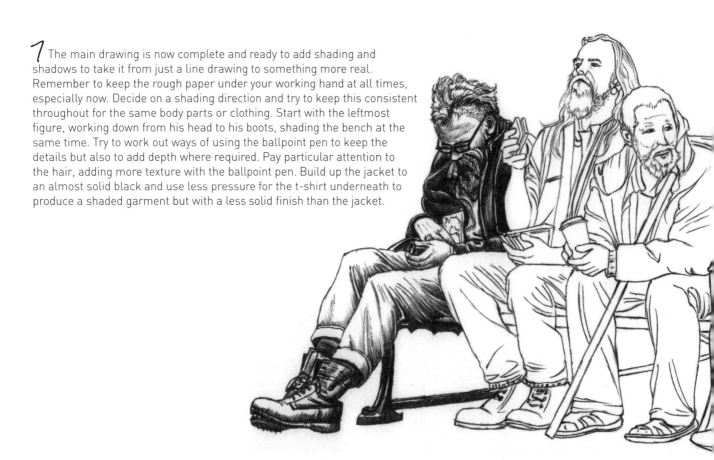

8 Continue to shade the remaining figures and sections of the bench, keeping your shading consistent and in the same direction in the same areas to match the other figures' features and clothing. When you complete an area of very dark ballpoint pen, ensure that any adjacent sections are lighter. Two dark areas next to each other will merge, so think about this prior to shading too heavily. The inset shows an example of this: the long-haired man's arm is in between the darks of two jackets. As the arm is mostly light, this works, but if the sleeve were rolled down, the arm would have disappeared into the background.

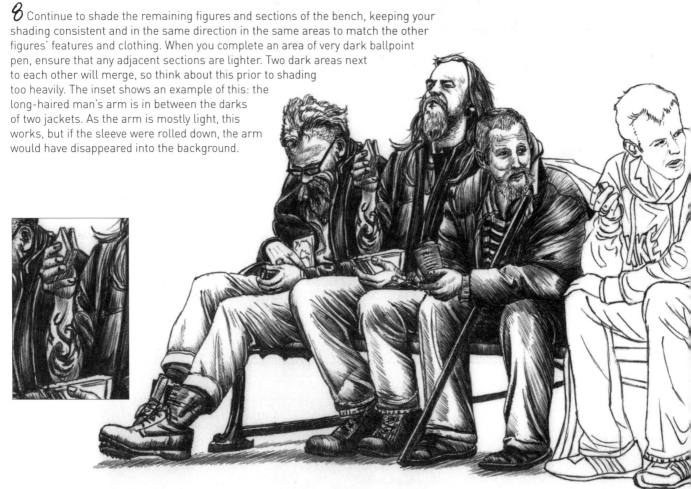

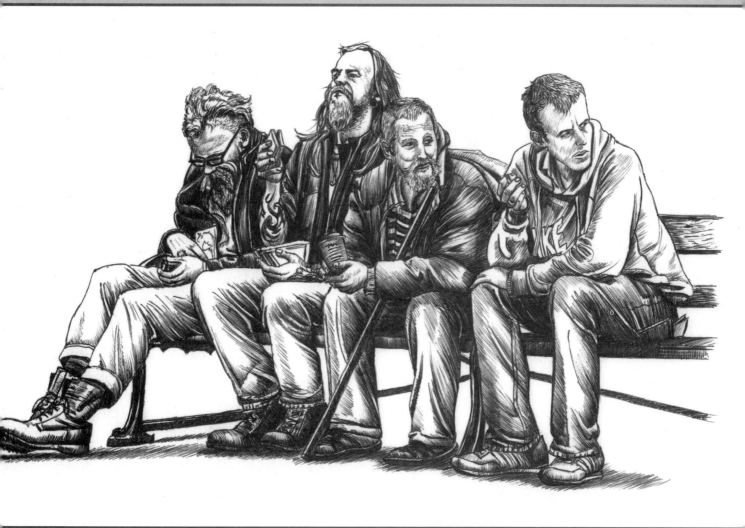

9 With all of the figures completed, shade the remaining part of the bench. Allow it to fade off to a vignette effect on the right-hand side. Finally, reinforce the shadows on the ground cast by the men to finish off the drawing.

The finished picture
42 x 30cm (16½ x 11¾in)

Black ballpoint pen on smooth white board.

Index